WHERE THE HELL IS MATT?

Dancing Badly Around the World

Matt Harding

Skyhorse Publishing

Copyright © 2009 by Matt Harding

All Rights Reserved. No part of this book may be reproduced in any manner without the express written consent of the publisher, except in the case of brief excerpts in critical reviews or articles. All inquiries should be addressed to Skyhorse Publishing, 555 Eighth Avenue, Suite 903, New York, NY 10018.

Skyhorse Publishing books may be purchased in bulk at special discounts for sales promotion, corporate gifts, fund-raising, or educational purposes. Special editions can also be created to specifications. For details, contact the Special Sales Department, Skyhorse Publishing, 555 Eighth Avenue, Suite 903, New York, NY 10018 or info@skyhorsepublishing.com.

www.skyhorsepublishing.com

10 9 8 7 6 5 4 3 2 1

Library of Congress Cataloging-in-Publication Data

Harding, Matt.
 Where the hell is Matt? : dancing badly around the world / Matt Harding.
 p. cm.
 ISBN 978-1-60239-652-4
 1. Harding, Matt. 2. Dancers—United States—Biography. 3. YouTube (Firm) I. Title.
 GV1785.H279A3 2009
 792.802'8092—dc22
 [B]
 2009012841

STRIDE is a registered trademark owned by Cadbury Adams USA LLC

Photo Credits
Page 138 © Rodrigo Fernandez
Pages 150-153 © Rob Cantor

Printed in the United States of America

WHERE THE HELL IS MATT?

To Melissa, for showing me what this book is about and then telling me, because I missed it the first time.

Contents

Introduction	xi

Part One: Nerd Wanderlust — 1

Sühbaatar, Mongolia	3
Siberia, Russia	6
Kilimanjaro Summit, Tanzania	9
The Impenetrable Forest, Uganda	20
Angkor, Cambodia	24
Prague, Czech Republic	27

Part Two: Famous on the Internet — 29

Neko Harbor, Antarctica	33
Tikal, Guatemala	38
Galápagos Islands, Ecuador	44
Machu Picchu, Peru	49
Salar de Uyuni, Bolivia	53
Easter Island, Chile	57
Jellyfish Lake, Palau	62
Chuuk, Micronesia	65
Dubai, United Arab Emirates	73
Mulindi, Rwanda	75
Mokolodi, Botswana	78
Sossusvlei, Namibia	82
Abu Simbel, Egypt	88
Ephesus, Turkey	92
Athens, Greece	96
Kjeragbolten, Norway	100
New York, New York	106

Part Three: Once More Around — 109

Lisse, The Netherlands	113
Batik, Morocco	116
Timbuktu, Mali	123
Antsiranana, Madagascar	127
London, England	130
Seljalandsfoss, Iceland	133
Madrid, Spain	138
Israel and the West Bank	141
Vancouver, British Columbia	145
Montreal, Quebec	148
Washington, D.C., United States of America	150
Los Angeles, California	154
Tongatapu, Tonga	156
Vava'u, Tonga	160
Wainivilase, Fiji	162
Auki, Solomon Islands	164
Poria, Papua New Guinea	168
Brisbane, Australia	173
Lancelin, Australia	174
Christmas Island, Australia	176
Tokyo, Japan	181
Seoul, South Korea	186
Demilitarized Zone, North Korea	189
Nellis Air Force Base, Nevada	193
Sana'a, Yemen	197
Kuwait City, Kuwait	203
Ala Archa Gorge, Kyrgyzstan	207
Gurgaon, India	212
Alhambra, California	217
Seattle, Washington	221

Conclusion — 225

Acknowledgments — 227

Introduction

"Hey, stand over there and do that dance you do. I'll record it on your camera."

When Brad spoke those words near a busy street corner in Hanoi, he didn't know he was profoundly altering the course of my life. Over the next five years, standing *over there* and doing my dance would send me to seventy countries on all seven continents; to the ocean floor and to mountain peaks; to the poorest, most crowded places on earth and to silent oases where few other humans have set foot.

I did not plan to become famous on the Internet for dancing badly all around the world. It just happened. And it started with a spontaneous, goofy idea.

In the summer of 2003, digital cameras were just becoming cheap and portable. Internet video was on the cusp of ubiquity. And budget travel was easier and safer than ever, allowing backpackers to wander just about anywhere on the planet. When Brad, my friend and former coworker, made that simple suggestion during our trip through Vietnam, he placed me at a fulcrum. Culture and technology had converged to create an enormous opportunity. All that was needed was a visual hook to hold peoples' attention. Turns out, dancing badly was just the thing.

I've been dancing that way for as long as I can remember. It's the only dance I know—and I realize I'm using the term charitably. I jump up and down and swing my arms. It's what my body feels like doing when it's happy. Brad knew the dance because I used it to pester him at work when it was time to go to lunch. I'd hover in front of his desk, snap my fingers, and dance until he gave up on whatever he was doing and came with me to get something to eat.

In the beginning, the formula for shooting dancing clips was only a slight variation on standard tourist snapshots: pose in front of famous landmark, click, move on. I could've just as easily been carrying some stuffed animal, wearing a funny hat, or hanging spoons from my face, but it happened to be dancing, and that added something special. It was a long time before I understood what that something was. Back then it was just a fun, fast, and cheap way to capture mementos

from the interesting places I visited. I figured I'd enjoy looking back on down the road, and that it might amuse my friends and family.

It became a lot more. This book is the story of how that happened.

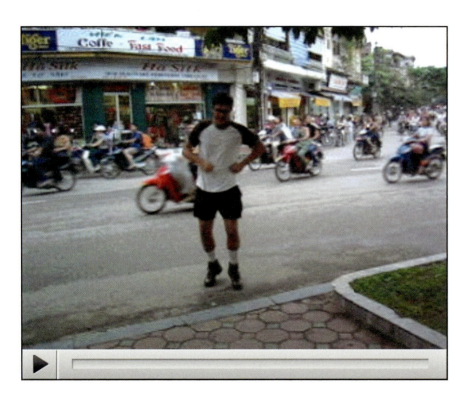

Part One:
Nerd Wanderlust

"I'm quitting."

"You're quitting?"

"Yeah, I'm done. I've gotta go."

That was the first time I said it out loud. I'd known something was wrong for a long time, but I didn't know what to do about it. Until I told my boss, Andy, that I was resigning from my job, it hadn't occurred to me that I *could* do anything about it.

All my life, all I wanted to do was make videogames. Growing up in Connecticut, I was a terrible student. In my junior year of high school, my father told me he didn't want to send me to college because I clearly wasn't interested. He encouraged me to find my own path. So while my friends left home to pursue degrees, I worked as an assistant manager at a videogame store. That led to a job as an editor at a videogame magazine, which gave me enough knowledge and experience to land a position, shortly before my twentieth birthday, as a game designer at Activision in Los Angeles.

Living in Los Angeles didn't suit me much, but I still thought I was the luckiest guy in the world. My life became a rhythmic migration from bubble to bubble: car, work, car, apartment, car, shopping mall, and so on. I found it hard to make friends. I found it hard to break my routine. I felt a need to grow and discover, but it just wasn't happening for me.

A few years later, I was working at Pandemic Studios when two of my coworkers, Andy and Adam, announced they were moving home to Australia. They'd had enough of Los Angeles, too. They were valued programmers, so the head of the company offered to start a satellite office down there, which would allow them to continue working for the company. When I heard the news, I begged them to take me along.

In 2000, I moved to Brisbane, Australia and my circumstances improved considerably. I had friends. I went out. I did stuff.

I learned two things from Australians that had a lasting impact on me: I learned to drink alcohol, and I learned how to travel. Growing up, travel wasn't big on my radar screen. My family went to the Caribbean every year in the spring, and there were frequent excursions to Disney World, but I had no idea you could simply hop on a plane, go somewhere strange

and distant, and sort yourself out once you got there. For Australians, this was a common rite of passage. They would finish university, say "Bye, Mom. Bye, Dad," and then disappear for a couple years with little more than a vague plan and a shoestring budget.

As I got older, I got the sneaking suspicion that I was missing out on something. Sitting in front of a computer all day at the office, getting pastier and fatter, it seemed my attempt to find my own path had led me astray. I'd become increasingly aware of the larger world around me, but still I felt cut off. Suddenly, I wanted very much to be a part of it.

In late 2002, the game we were working on was canceled. It was a game for kids about cute little creatures that popped into balls and smacked into each other. My team was thrilled to be working on it, and we were crushed to lose it to the unfortunate reality that no one wanted to play it. By that point, tastes had "matured." A series called *Grand Theft Auto* had become enormously successful, and publishers wanted to imitate that success with more games that were explicit, brutal, and generally nihilistic.

We had the option to either come up with an original idea that we could sell, or get stuck churning out a game based on some third-rate movie or TV show license. Out of frustration, I proposed exactly what I figured publishers wanted. The pitch went like this: "You play an alien who invades earth. Your job is to blow up everything and kill everyone. We'll call it *Destroy All Humans!*"

Apparently, I was spot on. The game was greenlit and put into production. It eventually dawned on me that I'd self-sabotaged my career by conceiving a project that I absolutely did not want to make.

And so, at the age of twenty-six, I took Andy out for a drink and told him I was resigning. He was disappointed at first, but he knew I'd stopped caring and had become pretty useless at my job. The game got made without me, and it actually wound up being a lot of fun.

"Where are you headed?" Andy asked. "Back home?"

"Where's home?"

There wasn't much pulling me back to Connecticut. I knew L.A. wasn't the place for me. I only had one real obligation at that point, and I'd just relinquished myself of the burden. Suddenly I had nowhere in particular that I needed to be.

"I don't know," I said. "I've got some money saved up. I guess I'll just wander the planet for a while."

"Where do you want to go?"

" . . . Everywhere."

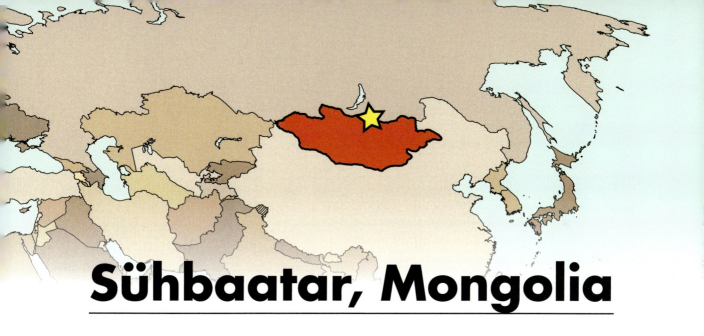

Sühbaatar, Mongolia

I did not order the boiled sheep's head.

Brent did. Brent is Australian, which means he's predisposed toward inadvisable behavior that results in a good anecdote. Brent and I stuck together from the moment we were introduced, but I had no interest in following him on the sheep adventure.

The head was brought to the table in ceremonious fashion, looking more or less how it would have when it was still attached to a body. The skin and hair were gone, but it still had its ears and its tongue. The eyes were white, like a zombie's.

Our guide went straight to work on his own sheep's head with knife and fork, carving off the cheek, the lips, the tongue, and finally digging into the brain. His cuts were fast and deliberate, disassembling the sheep's cranium and extracting every morsel. The rest of us just sat there with pale faces, Brent included. He tasted a bit of it, to his credit, but he was out of his depth.

After dinner, I strolled outside to lie in the grass. We were in a campsite of traditional Ger tents, far from the city among the endless rolling hills.

I was enthralled by the clarity of the stars. I noticed one star moving quickly across the sky, and eventually figured out that it was a satellite reflecting the sun's light—something I'd never seen before.

When our server, Chuluun, finished cleaning up after our meal, he came out and joined me. He spoke a little English and enjoyed talking to Western guests. I asked him if he'd ever seen a UFO. He was unfamiliar with the word, so I attempted to clarify: "Uh, spaceship. Aliens. Flying saucers. Men in Black."

There wasn't a trace of recognition. I tried a different approach.

"Have you ever seen a bright light that moved quickly across the sky in different directions?"

"Oh, yes," he said. "I have seen."

"Not like that satellite," I said. "Bigger. Faster."

"Yes, yes. I have seen."

"Was it an airplane?"

He said no. He knew what airplanes looked like, and it was different. I asked him to describe what he saw.

"It is like a star, but it moves very fast and changes direction."

Amazed, I asked if he knew other people who'd seen what he was describing.

"Yes. Everyone sees this. Maybe one time. Maybe two times in whole life. We have a word." He told me the word in Mongolian. "In English it means 'star that moves very fast and changes direction.'"

Brent and I left by train into Siberia. Crossing the border is a tedious process for foreigners. Our train car was separated from the others and we were left alone on the tracks for several hours. During this time, we could not move from our cabins—not even to go to the bathroom. The Russian border guard came in to inspect us. We were told to never under any circumstances smile or laugh when talking to the inspector, or we could be denied entry.

When it was over, we were allowed to step off the train for a bathroom break. Having neglected to shoot a clip during my visit to Mongolia, I snuck around the corner of the immigration building and got Brent to hold the camera while I danced a few feet from the border.

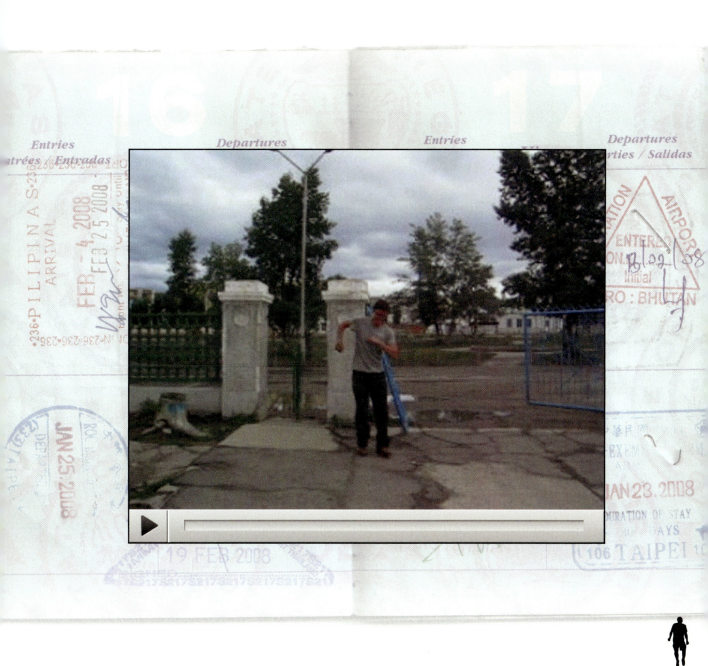

Siberia, Russia

 I spent the next six days on the Trans-Siberian Railway (or as I prefer to call it, the Bleak Streak), traveling to Moscow. Brent and I were thrown into a cabin with two other passengers of a similar age and circumstance: Rohit, an American film student, and an Irish girl named Rose.

 We ate a lot of cheese and sausage. We drank a lot of vodka.

 The size of our cabin made us all get to know each other intimately. My bunkmate, Rohit, had a snoring problem. His middle-of-the-night wheezes reduced Brent to fits of bleary-eyed hysteria.

 After a few nights of it, I turned on the microphone built into my laptop and recorded Rohit going full blast. I then boosted my speakers to maximum volume, set the laptop behind his head, and played his noises back to him. He jumped out of bed and asked, "Who's snoring?"

 Gleefully, we all shouted back, "You! It's you!!!"

Each car is assigned a *provodnitza*. *Provodnitzas* are invariably female, and seem to be a vaguely defined combination of conductor, maid, and prison guard. They are notoriously punitive. At one point our *provodnitza* got fed up that we were not fully closing the door between carriages, so to teach us a lesson she locked us into the dining car while we were playing cards. We found this deeply alarming, as theft is fairly routine on Russian trains and our cabins were easily accessible to other passengers. She waited for several minutes while we banged and screamed before letting us out.

Lesson learned.

We had brief opportunities to step off the train once or twice each day. Usually, all we could do was pick up grim offerings like smoked fish and boiled eggs from old ladies who wait by the tracks. Occasionally, we'd get a chance to wander a few blocks into the larger cities before the train departed.

As we approached the station in Omsk, I read in my guidebook that it was home to the world's largest Lenin head. I have a condition that renders me incapable of turning down an opportunity to see the world's largest anything, so I convinced Brent to come with me and find it.

We arrived at 2 a.m. and we had forty-five minutes to explore before the train was to leave. We set out with no map, no money, no passports, and not even the slightest idea where this Lenin head was to be found. We were soon lost.

We wandered toward what felt like the city's center, but I was truly winging it. At long last, Brent stopped and asked me, "What *is* a lemonhead, anyway? And why do they make them so big here?"

I realized he hadn't the slightest idea what we were doing, but was no less enthusiastic for not knowing. If you have the opportunity, I highly recommend traveling with an Australian.

We eventually wound up finding the world's largest Lenin head. It looked like Lenin's head and it was really big.

We heard the train whistle blowing in the distance. We immediately began sprinting. I'd lost over twenty pounds since I started the trip, but I still wasn't much of a runner. My legs gave out and Brent took off ahead of me. He got onboard and begged the *provodnitza* not to let the train leave until I returned. She didn't understand a word he was saying and didn't particularly care.

As the train wheels started grinding along the rails, I reached the rear carriage,

grabbed hold of the handlebar, and climbed inside.

 Ideally, I would have been able to shoot a dancing clip with the Siberian tundra framed in the train's windows. Unfortunately, the floor plan left limited compositional options. I enlisted Brent to hold the camera for me again while I squeezed into the corridor and let loose with all the jubilance the space would allow.

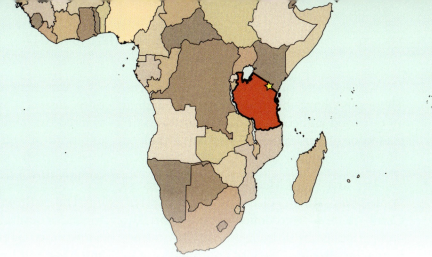

Kilimanjaro Summit, Tanzania

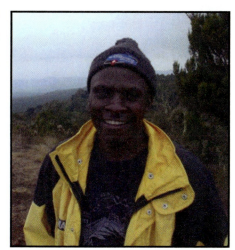

Months later, in Kenya, I met up with Andy, my close friend and former boss. Soon after I left to go traveling, it dawned on him that he could do the same thing, so he resigned and invited me to join me on a hike up the tallest mountain in Africa.

At the base camp, I rented most of the gear I lacked: a sleeping bag, warm gloves, two metal walking poles, a headlamp and balaclava for the final ascent, and a pair of almost-sort-of-close-to-fitting mountain boots.

We met our guide, Mecke.

We were also supplied with three porters. These guys have the grueling job of lugging all our food and cookery, as well as up to fifteen kilos of our luggage—the loads balanced effortlessly on their heads.

The first thing Mecke told us was to go "*pole pole*," which is Kiswahili for "slowly." Climbers feel overconfident, walk briskly, and get nailed by altitude sickness (vomiting, headache, dizziness, lack of coordination).

We passed a steady stream of climbers going in the opposite direction. You can't help but stare—these people were on their way down from the summit.

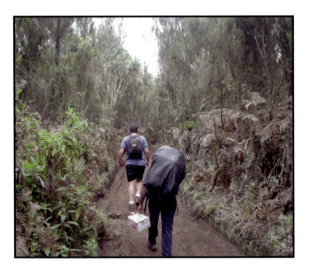

Did they make it, or were they retreating in shame?

I was tempted to ask, but I realized the only answer I wanted to hear was "no." I wanted to maintain my feeble illusion of exploration and conquest, despite the well-trodden path and the hundred or so climbers coming down from the top each day.

The path wound on through lush green forest for several hours, at points intersecting with the straight, wide dirt road the porters run back and forth along.

In time it got colder, the trees a bit sparser and lower. By early afternoon, we reached camp.

On that first night, less than halfway to the top, I had already started feeling the effects of the higher altitude: a light walk from our cabin to the meal hut and I'd have to pause for a deep breath. This was a serious concern. Fortunately, Andy and I both had our bottles of acetozolamide, the standard medication for preventing and treating altitude sickness.

Not long after leaving camp the next morning, we got our first glimpse of the summit. I found myself drifting in front of Mecke more and more. "*Pole pole!*" he'd warn at regular intervals. But off I went.

At a rest stop, I met a porter named George and his friend, Yaphet. George invited me to continue on with him.

This was only George's third ascent up Kilimanjaro. He hoped to become a guide someday, but porters pay for guide training out of their own pocket. Only a small percentage pull it off after years of saving—they get tipped around ten dollars for their six days on the mountain.

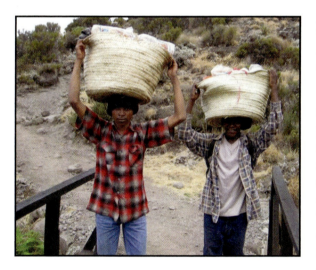

The food the porters eat comes directly out of their pay, so they get by on as little as possible. Many of them die of exhaustion. Others die from hypothermia near the top, and still others die from untreated altitude sickness. While the guides rush climbers down the mountain at the first sign of trouble, porters just have to cope.

I looked up from our conversation as, all at once, the fog we were walking through went away. On a flat, open hillside, I could see that I'd risen above the first cloud layer. And not long after that, the second campsite came into view.

It is strongly recommended that climbers pay extra for a day of rest around the halfway point. This gives your body more time to adjust to the altitude, and reduces the chances of altitude sickness further up.

At dinner we met a German guy who was coming down from the summit. He complained that his porters refused to carry his walking poles during the final ascent. He announced in the delicate, hushed tones that come so naturally to Germans, that because of their snub, he wasn't going to tip them. The porters overheard, along with everyone else in the tent. After the meal, they confronted him. With a day of hiking still ahead, he confirmed they would not be getting a tip. They dropped his bag and left him where he stood.

The route for day four would take us up another full kilometer—much higher than I'd ever been in my life.

Andy came by as I geared up. "The weirdest thing just happened," he said. "One of the porters asked if he could have his picture

taken with me. He put his arm on my shoulder, his friend took the picture, and they walked away. What was that about?"

"You really want to know?"

"Well, yeah."

"They think you're Elijah Wood."

"Fuck off!"

"They think they're hauling Frodo Baggins's crap up a mountain."

Here's where I did a really bad thing. While Mecke was getting ready, I took off on my own. Looking back now, I can't really explain it in any sensible way. I wanted to be alone, I wanted to get it over with, and—this sounds so stupid—I didn't want to worry about keeping a slow pace. I was too anxious.

As I progressed, the plant life became gradually smaller and sparser, until I cleared a hill and saw a thin, undisturbed path stretching on for miles in front of me. I had suddenly arrived on another planet.

At the end of the straightaway, a deceptively steep hill led to Kibo Hut, the final campsite. I checked in and was directed to a dorm room with twelve bunks packed close together. I flopped down and rested for a solid hour before the next climber showed up.

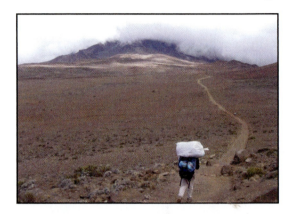

When Mecke and Andy arrived, Mecke was visibly pissed at me for ignoring his advice. My own blunders aside, the mood around the camp was understandably tense. We knew not everyone was going to reach the top—a few were already on their way down. It was even possible that someone might die. Everyone was quiet and focused.

The trail out of Kibo is obscured by rocks, so we couldn't see much of what was ahead of us. All we knew was there would be a long, steep climb to a place called Gilman's Point, followed by a shorter, more level walk across the top of the mountain to the absolute summit, Uhuru.

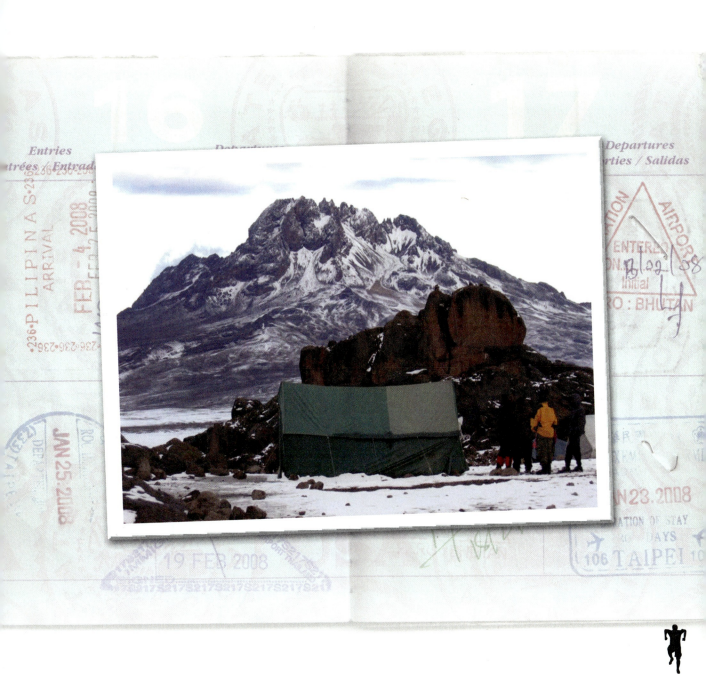

Mecke introduced us to Joseph. Joseph was an assistant guide who would be joining us for the final ascent. The role of the assistant guide is to bring up the rear and watch for signs of altitude sickness.

There's a very small window of time, just after dawn but before the morning clouds roll in, when it's safe and warm enough to reach the summit. For this reason, the final ascent has to begin at the less than ideal hour of midnight. I lay in bed staring at the ceiling until the door creaked open, signaling the start of the main event. With no electricity, we shuffled around in the dark, getting our gear on and wolfing down a plate of tea and crackers.

Mecke, Joseph, Andy, and I gathered at the start of the trail, donned our silly-looking head-mounted flashlights, and off we went in single file.

The next few hours don't sit in my mind the way normal memories do. It seemed to go on forever, and yet, with so little sensory input, the endless trudging through darkness also seemed to happen in a blink.

Step. Step. Step. Step.

Don't look up, I thought to myself. *Don't think about how far you've gone. Shut your brain down. Just keep stepping.*

Step. Step. Step. Step.

This isn't so bad. I can do this for a while. How much time has passed? How much have we done? 10 percent? 20 percent? 2 percent?

Just keep going. We'll get there.

I lost my balance. Stumbled a bit on some rocks.

Andy said, "How you doing, Matt?"

"I'm okay. How about you?"

"Fine. This isn't so bad."

"Yeah."

Too tired to talk. Focus on the steps. Don't look up. Don't look up.

I wonder what the stars look like.

I looked up. I saw the Milky Way galaxy, almost as it would appear from space, above the haze of the lower atmosphere. It was a dose of what forever looks like—a sight that would make me fall to my knees under any other circumstances.

"When do we rest?"

"Almost to cave." Mecke said. "We stop there."

Almost to cave. Almost to cave. What is he talking about? This isn't "almost." I need to stop. No, I can't stop. Wait until Mecke calls a rest. We're almost there.

"Okay. Here is the cave. Stop for three minutes. No more."

"I need more than three minutes, Mecke. I'm exhausted."

"Can't stop long. It is very cold. Must keep going to stay warm."

The cave wasn't much of a cave. I tried to drink some water. The bottle was frozen. I opened an energy bar. My hands weren't working very well. I couldn't hold the bar steady. It was frozen too. I nearly chipped a tooth trying to get the thing down.

"Okay. Time to go. Matthew."

"Yes!"

"How are you?"

"I'm good. Just a second."

Shit. I can't do this.

Meanwhile, Andy was having a great time. He was laughing and smiling. Goddamn Frodo Baggins.

I got up and saw a sign marking 16,000 feet. We'd climbed less than 800 feet since we left the hut and the summit was just under 20,000.

Only a few steps outside the cave, I was completely drained again. I kept going for another minute and then collapsed on a rock.

"Matthew!"

Get it together. If you're not clear and alert, they'll take you down.

"Yes!"

"How are you?"

"I'm okay. I just need a minute."

I got up and carried on. I was instantly exhausted again. Stopping just made me colder, but I couldn't walk straight anymore. I was tripping and stumbling all over the place. They could see it too. I collapsed on another rock.

"Matthew!"

"Yes!"

"How are you?"

"I feel dizzy."

"Dizzy?"

"Lightheaded. Like I'm gonna be—"

And then I was. Eight times, until my stomach was empty.

There's vomit everywhere. I'm shaking. I can barely stand. This is altitude sickness. I think I'm going to die.

Joseph put his hand on my shoulder, leaned in close, and whispered, "You are stronger than you know."

And I realized he was right. And I realized there are angels.

Turning back meant walking down everything I had just walked up. It was a known quantity that I couldn't bear to think about. The other direction, up, at least that was still blackness and I didn't yet know exactly how bad it would be. I obviously wasn't thinking straight, but it seemed like a better option. I wasn't thinking straight because I didn't have enough oxygen in my brain. I was choking on carbon dioxide.

"Joseph will go with Andrew to the top," Mecke said. "Matthew, I will stay with you and we will continue."

With each step, I moaned and wailed like a baby. I collapsed every fifty feet or so.

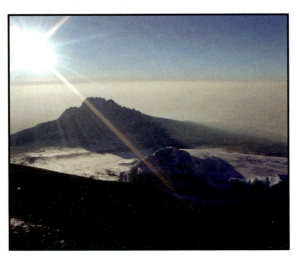

Mecke looked worried. He was trained to grab me by the armpit and haul me back to Kibo Hut as quickly as he could manage, but he wasn't doing that.

"Matthew!"

"Yes!"

"How are you?"

"I'm okay!"

I wasn't okay. For the last hour, I'd been ignoring a pressing abdominal emergency and it was getting worse. I was on a forty-degree incline, unable to feel my extremities, and I couldn't stop shaking. Under the circumstances, I couldn't carry out a much-needed number two. There was a looming possibility that I might reach the summit under very unpleasant circumstances.

I explained the situation to Mecke. "I have medicine," I told him. "It's in my bag."

"Give me your bag."

I passed it to him and he held it while I worked on the zipper. I took my glove off and struggled just to close my thumb and forefinger together and pull it open. He shined his light in the bag. The travel doctor had had me fill a prescription for Cipro, a strong anti-diarrheal medicine that comes in a childproof, twist-cap bottle.

I held the bottle in one hand and slowly closed my other hand around the top. I pushed down and twisted. It opened. I moved like a junky in withdrawal, tilting the bottle, my arm shaking terribly. I caught a pill in my hand. Up to my mouth. Swallow. Okay.

Maybe it was all in my head, but inside a minute the problem was gone—or at least delayed. Onward, ho.

We weren't walking up a slope anymore. We were climbing rocks. It was hard, but I knew it meant we were close.

Very close.

There was a huddle of people on the jagged rocks around the sign marking our arrival at Gilman's Point. No one was in very good shape. Andy wasn't there.

I received a telegram from my body:

NOTHING LEFT DOWN HERE STOP.
YOU ARE ON YOUR OWN NOW STOP.

"Matthew!"

"Yes!"

"Can you continue?"

I looked out and saw the first thin slice of the sun peeking over the horizon. I didn't think about the months of training. I didn't think about how it would feel to go down in failure. I didn't think about the very real nerve damage I was doing to my feet that would leave me hobbling on stumps for several months. I just watched the sun coming up.

"Yes!"

Did I just say that?

The air was thin, but I was walking on level ground and it was getting warmer. I could see the summit in the distance. And I could see Andy walking toward me on his way back down.

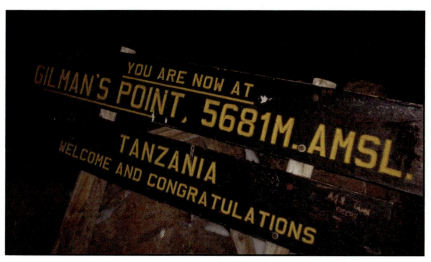

We hugged, and I was freaking crying.

"I'll see you at the bottom," he said.

Within minutes, Mecke and I reached the summit.

Before I started down, I had to shoot a clip for the dancing video. Despite all Mecke's virtuous qualities, he wasn't the best cameraman. I have several clips that end with me saying, "Three, two, one, go!"

I used the last drop of energy in my body to dance one more time. We got it right. As for what I used to get back down the mountain, I can't say I recall.

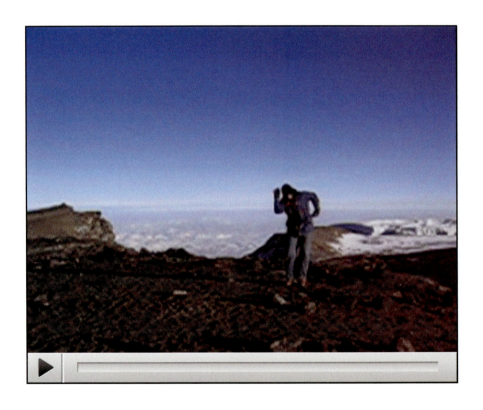

The Impenetrable Forest, Uganda

Andy and I parted ways after Kilimanjaro. He continued on his world tour, while I stuck around in Africa to explore. I spent a nomadic week traveling west through Tanzania. I woke up on a bus in Uganda sitting next to a young girl, maybe fifteen years old, at a roadside food stop. Hawkers were shoving sticks of meat at us through the windows. She bought one. I abstained.

"You don't eat meat?"

"Yes, I do."

"You eat pigeon?"

"Pardon me?"

"You have business?"

"... I can't understand you."

"I am your business."

"What do you mean?"

"You have mother?"

"Yes. I have a mother."

"I have no mother. No father."

"... I'm very sorry."

"I am your business. You take me."

"I—I can't. I don't understand."

"You have madam?"

"Do I have a madam?"

"You take me to hotel. I am your madam."

"Oh. I'm sorry. No. I can't do that."

She gave up after a while.

I reached the Ugandan capital of Kampala, where I purchased a permit to visit the Mountain Gorillas in the Impenetrable Forest, near the southern border. To protect the animals, the Uganda Wildlife Authority limits the number of visitors to a handful each day. A last minute pass cost me $350.

I'd already spent almost all my savings. I was running on fumes. The permit wasn't something I could afford, but then, how often does one get to visit wild mountain gorillas? And for that matter, how much longer would they even be around?

I spent the night at the edge of the forest with a half dozen other visitors. In the morning, the park rangers split us into two groups and we ventured in. I was with Ian and Tina from Alaska. Ian was a twenty-seven-year-old immigration officer. He'd recently enlisted to serve in Iraq. I asked him why he was going. His answer was disarmingly frank.

"I want to see some fucked-up shit."

As it happened, there was plenty of that to go around. We were escorted into the park by five Ugandan soldiers armed with Kalashnikovs. They weren't protecting us from gorillas. In 1999, a band of rebels from the Army for the Liberation of Rwanda kidnapped eight tourists and hacked them to pieces with machetes.

The three hundred Mountain Gorillas in the Impenetrable Forest represent about half the world's remaining wild population. They move around at their discretion, so park rangers are assigned to keep an eye on them at all times. This makes it easier to bring tourists to visit them, and presumably offers some protection against poachers, rogue paramilitaries, and general lunatics with assault rifles.

After several hours of hiking through the challenging but not-quite-impenetrable forest, we were told a gorilla family was a few hundred meters away. The guide instructed us to behave calmly and quietly. Clearly, dancing was not going to happen in their presence. Instead, I asked Ian to hold the camera for me while I shot a clip within earshot of the gorillas, but not so close as to get my head cracked open.

We then crept a bit further and caught sight of the family of five in the distance: three females, an infant, and a silverback. The silverback is the alpha male. He calls the shots and he's charged with protecting the group, so you've got to get his permission before you can come close.

Our guide taught us a gesture to perform in front of him. We were each told to make a fist and bang it against our chests one time. This indicates that we're friendly. The gorilla will acknowledge the gesture and sometimes perform it in return.

It struck me as profound that gorillas have a gesture for communicating friendship. And on reflection, I realized humans do too. It's one we take for granted, but as a traveler, I've found it invaluable in every place I've ever been.

Smile.

It's so simple and so easy. Curve your lips upward and you are speaking the same message in every language: *I pose no threat. I want to be your friend.*

We watched the apes laze around for a half hour. The silverback kept a close eye on us without losing his cool. Sitting just a few steps away, his tremendous strength remained present in my mind.

These are truly awesome creatures, and in all likelihood they'll soon be gone. I can mourn the loss, I can join the struggle to preserve, or I can simply acknowledge that their time has passed just like everything will pass, and appreciate the memory of having been there.

My flight out of Kampala was almost empty. I had the run of the back half of the plane. I hopped from side to side looking out at the Serengeti, Ngorongoro crater, and Mount Kilimanjaro.

Everything is beautiful from way up high. It was down below that I witnessed darkness like I'd never seen before. My outlook steadily dimmed as I moved further into the continent. The more I listened and learned, the less hope I found. Nevertheless, I felt drawn to come back and continue searching.

I pushed the seat back and grabbed my only remaining entertainment: a beat-up copy of *Moby Dick*.

THE IMPENETRABLE FOREST, UGANDA

"All [men] are born with halters round their necks; but it is only when caught in the swift, sudden turn of death, that mortals realize the silent, subtle, ever-present perils of life."

—Herman Melville

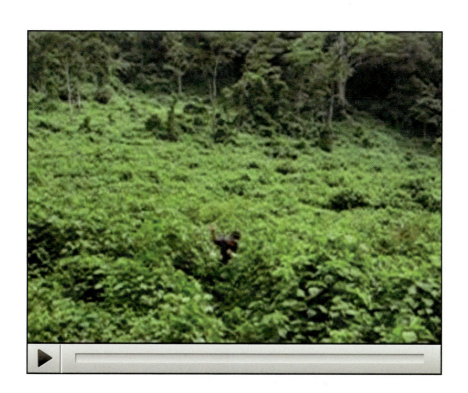

Angkor, Cambodia

My cousin Tom and I took the bumpiest road in the universe to the town of Siem Riep, on the outskirts of the ancient city of Angkor in Cambodia. The bus dumped us at a guesthouse that offered a room for three dollars, meals for two dollars, and a day tour on the backs of two motorbikes at six bucks each.

I've never seen anything that compares to the ruins of Angkor. The structures themselves are grand and imposing, but the flourishes made by nature in the centuries since it was abandoned add a whole other dimension.

Most historical sites are overrun with tourists, but Angkor's thousands of temples stretch over many square miles, so the traffic stays pretty light. We felt like we had the run of the place.

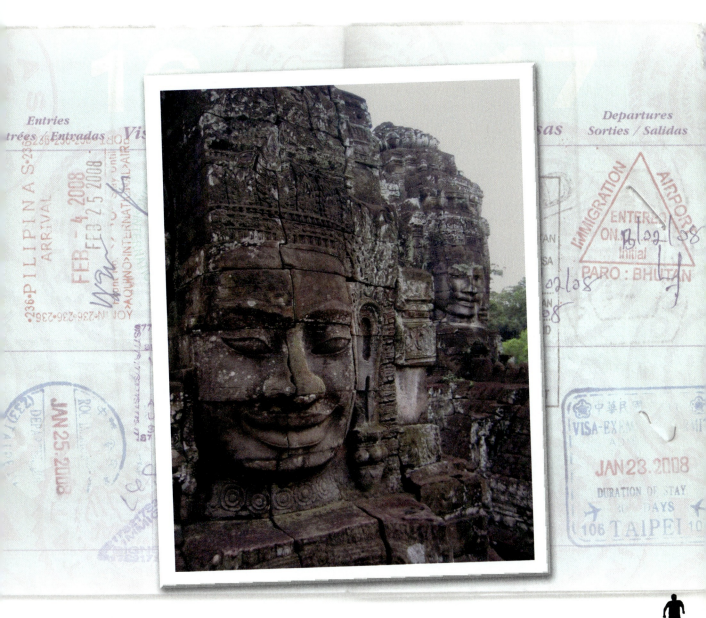

I danced at the Bayon temple, beneath some giant carved faces.

Tom encouraged me to let loose and try something different. The resultant flailing owes a debt to Steve Martin, whom I unconsciously channeled. From that point on, I decided to stick with the dance that came naturally.

Tom and I parted ways the next morning. The bus dropped me off near the Thai border, and I had to make the crossing on foot through a long, crowded corridor with all my bags. I felt something squirming in my pocket and looked down to see a hand that wasn't

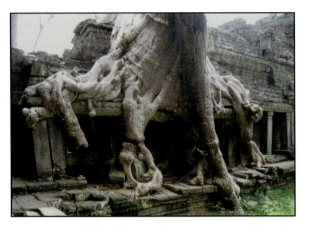

mine. I grabbed it and spun around. The hand belonged to a little boy, maybe eight years old. I made him open his fists and show me his palms. They were empty. My wallet was in the other pocket. I yelled at him to take off, and he did.

I was immediately struck by a wide assortment of emotions. I was frightened and angry, but I also felt ashamed of myself and I didn't know why. Part of me wanted to chase the kid down, apologize, and hand him some change. By that point, I'd developed blinders to the desperation all around me. The incident jarred me back to reality, but left me no wiser about how to cope with what I saw.

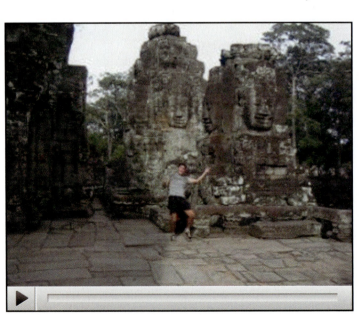

Prague, Czech Republic

My sister, Kristin, flew out to join me in Prague. I danced amidst the tourist throngs on the Charles River Bridge. She found my new hobby peculiar, but she was perfectly willing to indulge me and hold the camera.

We spent the rest of our time investigating two of my favorite figures from history: Danish astronomer Tycho Brahe and miserable genius Franz Kafka, both of whom are buried in the city.

Prague was my last stop on the trip. From there, I planned to stay with my mom in Connecticut for a while and eventually make my way to Seattle.

As much as I looked forward to going home, I didn't want to stop moving. I didn't want to be done. I'd found that travel had a way of prioritizing me. I stayed focused on the challenges of each day, and that made other problems fade into the distance. Making videogames was like that for a while; I could let everything else go because the game was all that mattered. I

had an excuse. But I grew up and realized it was an excuse not to live.

Each day at my job felt like one day closer to death; go to work, come home, watch TV, one whole day lost and gone forever. When I traveled, no time felt wasted. I was alert and active. I was switched on.

I felt like I'd been living in a cage and I'd only just learned there was no lock on the door. I could just walk outside and do as I pleased. I didn't want to get back in.

Timbuktu is calling me. The Galápagos are open for tourism. You can swim with humpback whales in Tonga. I never made it to the Gobi Desert or the Tunguska blast site. Venice is sinking and so are the Maldives. I still haven't seen a salt flat or an active volcano or the aurora borealis. There's a country called Wallis and Futuna. Zanzibar.

Zanzibar!

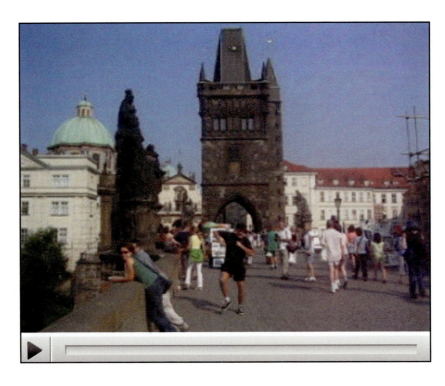

Part Two:
Famous on the Internet

At the end of 2004, I was living in Seattle with no job, no money, and no prospects. I had walked away from a promising career to search for something better, and though travel had become my passion, I eventually had to settle back down and start over.

I found a contract writing job on a videogame, but all I could think about was saving up enough money to continue exploring.

The one bright spot in my life was my girlfriend, Melissa. She found me on the Internet a few short weeks after I moved to town. Smart, pretty, funny, nerdy—she appeared out of the blue as soon as I stepped off the bus.

Does everyone get one of these?

At first it seemed too good to be true. And, well, it still does. Sometimes the right thing just drops in your lap and all you have to do is not screw it up.

Melissa put up with me in spite of my determination to avoid holding down a steady job. I moved into the cheapest apartment I could find and spent most nights at her place. I felt like a charity case. Unwilling to face up to the reality of my situation, I slipped into depression.

In my ample free time, I put together the footage I'd collected of me dancing badly in exotic locations. I slapped a song called "Sweet Lullaby" by Deep Forest over the visuals. It seemed like a good fit.

On the night of the 2004 presidential election, my family gathered to watch the results. When it was clear that we were heading into another four years of arrogance and stupidity, I put my laptop on top of the TV and tried to cheer everyone up by showing off the video I made.

My family found it mildly amusing.

On January 7th, my sister, Kristin, remembered the video and decided she wanted to show it to a coworker. She asked me to post it on my site and send her the link. A week later, my friend George found the video and linked to it on his blog, and another week later it made its way to a bigger local blog called Electrolicious. About three hundred people linked to the video from there.

The following week, it appeared on a forum site called MetaFilter, where communities of supergeeks collect and share links to random Internet junk. That triggered a thousand views. Next it showed up on a similar site called SomethingAwful, which triggered twenty thousand more overnight.

These communities are what you might call *discerning*; their tastes lean toward the ironic and cynical. And here, submitted for their review, was an utterly unselfconscious video of a guy reveling in his inadequacies. I braced myself for a merciless drubbing. Much to my surprise, they loved it. The bad dancing seemed to disarm the most jaded of viewers, and the stream of far-off locales stirred in them a sense of possibility. The overriding sentiment from the forum commenters was a sudden desire to stop letting life pass them by. People were actually inspired.

By February, I could tell from my site statistics that traffic from blogs and forum sites was dropping off, but more and more people were coming to it from links embedded in their e-mails. That meant people were passing the video to their friends. It had become "viral."

In the months that followed, there continued to be seemingly random spikes of interest. Someone in Germany would send the video around, and suddenly I was getting loads of e-mails from Germany. A week later, the same thing would happen in Italy, then Japan.

In August, a much larger spike occurred. Suddenly, it was discovered by the mainstream media. I was driven in a fancy town car to a local studio for a live interview with MSNBC. The next day, I was on *Inside Edition*.

I happened to be leaving on a road trip across the U.S. with Sophie, my friend from Australia, so I continued tracking my Internet famousness from the road. I was getting hundreds of e-mails a day. I got a very nice one from Walter Cronkite. He simply said he enjoyed what I was doing. I suppose it could have been someone posing as him, but what kind of deranged lunatic pretends to be Walter Cronkite?

Sophie and I checked into a Best Western in New Mexico. The clerk asked us which way we were headed. We told her we were going to New Orleans.

"Oh, no you're not."

"What do you mean?"

She pointed to the television. A Category 5 hurricane named Katrina was heading straight for the city.

We made it as far as Houston, and then instead of continuing on, New Orleans came

to us. We watched the buses full of evacuees pull up in front of the Astrodome from our hotel across the street. Everyone who could afford a room came over and got one.

Sophie and I sat in the lobby listening to their stories. We offered our car to anyone who needed it, and wound up taking a man named Edgar to Wal-Mart to pick up basic supplies. Over dinner, he described what happened.

"I rode out every storm since 1947. Thought I could ride out this one."

"When did you know you couldn't?"

"When the levy broke. I was in my living room and I heard that sound in the distance. It was the water, and it was saying, 'I-I-I-I'm comi-i-i-ing to *get* yo-o-o-ou!'"

Edgar lost his home and his taxi cab in the flood, and he hadn't yet gotten in touch with his two daughters or his five grandchildren.

"They'll be okay," he said. "They take after their father. Resourceful!"

Edgar helped me put sudden Internet fame in perspective.

When I got home from the trip, I got a call from a promotions agency working on a new product called Stride gum. They asked if I was interested in making a new dancing video. They said they'd pay for me to travel around the world. I said "sure."

Sometimes the right thing just falls in your lap.

They said they needed the video ready on June 21, 2006—the day Stride gum was to be released on the market. If I spent the rest of the year preparing for the trip and left a couple weeks at the end to edit, that gave me five months to see the world.

The Stride gum folks set up a meeting in New Jersey to discuss the idea in person. I went to a local travel bookstore and bought the biggest map of the world I could find. I pinned it to my bedroom wall and drew a dotted red line connecting all the destinations I wanted to see into one massive route. It was seventy-three countries in all. I did the math on a five-month trip to seventy-three countries and realized I'd never make it out of the airport, so I pared it down to a slightly more reasonable thirty-nine.

I brought the giant map to Stride gum's offices and unrolled it across their conference room table. My main contact, Emily, seemed tickled by my enthusiasm, but she wasn't all that concerned with the details. We worked out a budget that allowed me to do what I wanted to do, and I derived a fee from what I didn't spend traveling. She said "We love what you're doing. We want to help you. We don't want to mess with you."

That works for me.

Neko Harbor, Antarctica

When it was announced over the ship's PA that we'd soon see our first iceberg, they made it out to be a really big deal. I wasn't sure why. I imagined myself getting all bundled up just to see a tiny white chunk floating in the water. It hardly seemed worth the bother.

Turns out it was very much worth the bother.

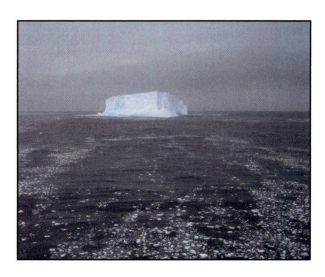

As we moved south, the ocean's surface became covered over with ice. It looked like solid ground, but the ripples of the current made it undulate slowly, creating a hypnotic effect. The layer of ice also dampened the sounds of the sea, leaving us in perfect silence.

It felt like we'd invaded someone's dream space. Our ship, a Norwegian icebreaker called the *Polar Star*, fired all four engines so that its reinforced hull could continue battering its way toward the frozen continent.

In an age when you can hop on a plane and reach virtually any place on the planet within forty-eight hours, a special appreciation is needed for the Odyssean hurdles that must be overcome to reach Antarctica.

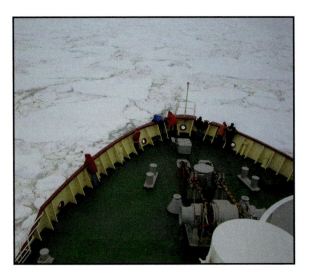

. . . Granted, the ship did all the work. I mostly just sat around.

For three days, we cruised across the Drake Passage from Ushuaia at the tip of Argentina. The Drake Passage circles around Antarctica, spanning the only latitudes in which there is no land the whole way around, which means the currents swirl uninterrupted and create the roughest seas on earth.

Of the hundred or so passengers, few of us were spared from seasickness. It hit me in the library when I got a little too engrossed in my Game Boy and neglected to stare out at the horizon. I burst out onto deck 5 and unleashed everything I had onto deck 4.

We all tried to stay distracted. There was an ornithologist onboard, and I was able to absorb some of his bird-watching enthusiasm through osmosis. The wandering albatross was my favorite, with its wingspan of twelve feet and an unusually poetic name. It uses updrafts to glide over the water for days on end, searching for food. But when someone would spot a southern sooty snow petrel or whatever, I'd retire to the ship's bar and order a tall glass of who-gives-a-crap.

There were also minke whales, fin whales, and orcas. Fur seals berated us as we passed by the ice floes where they rested, and penguins scurried hither and thither to escape our path.

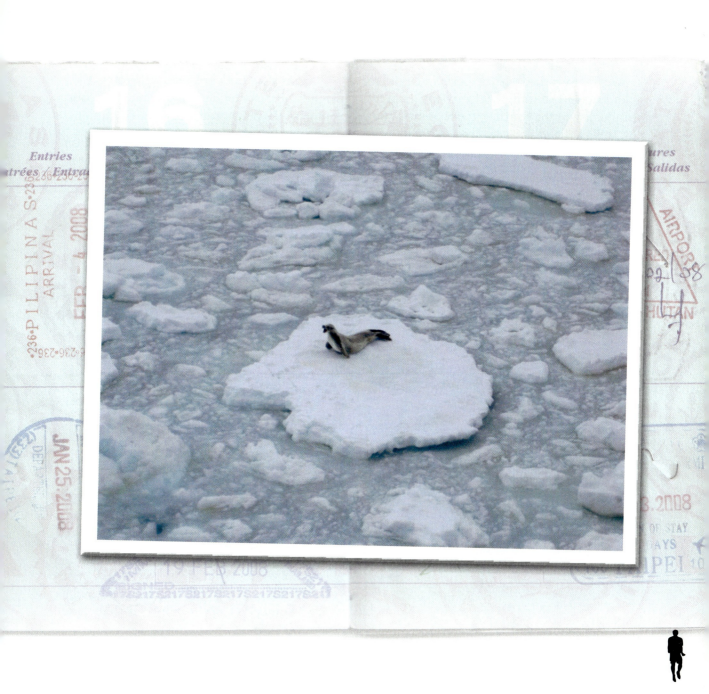

We finally pulled up at Peterman Island to make our first landing. At sixty-five degrees latitude, it was the southernmost point of our trip. It was 9 p.m., but still broad daylight in the height of Antarctic summer.

The expedition staff always landed before us and set down bamboo markers that defined our outer boundaries. We had a couple hours to explore on our own. At Port Lockroy, there stands a small shed with an unmanned office. Inside the office is a vaguely official-looking stamp that confirms entrance to Antarctica. We couldn't visit it as passengers but a member of the crew was sent off with all our passports. We came to Antarctica and we wanted our damn stamps to prove it.

Peterman Island is filled with penguins.

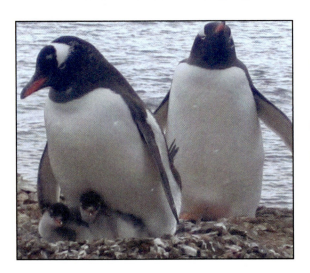

Penguin pictures are very easy to take, as penguins are extremely photogenic and completely indifferent to the presence of humans.

I had purchased a stuffed penguin doll on the ship to give to my niece for Christmas. I tried integrating it with the penguin population.

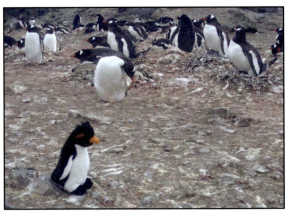

They were as oblivious to its presence as they were to ours, and to anything else that wasn't actively trying to eat them.

The next day, on Danco Island, we hiked up a two-hundred-meter hill for a panoramic view of the region. It proved harder than it looked to trudge through the snow. Only a few of us made it to the top.

The thought of hiking back was too much to bear. Someone had the epiphany that there was another, much easier way to get down.

NEKO HARBOR, ANTARCTICA

Impromptu butt-sledding down a hill in Antarctica was a good idea.

Neko Harbor was the only stop on our trip that actually took us onto the continent proper rather than an outlying island. A high rock outcropping looked across at glaciers jutting out along the bay. It was one of the warmest days of the year, so glacial calving was in full force. A few of us sat and watched as huge chunks of ancient ice slid into the water; their apocalyptic crashes echoing off the mountains.

I figured it was a pretty good opportunity to dance, but I couldn't bring myself to ask everyone to clear out of the shot. Instead, I waited politely while the sun beat down on my skin with barely a scrap of ozone to filter its rays. Some passengers applied sunscreen before each landing. I was not one of them.

After a half hour or so, the others finally took off, leaving me alone with Jørn, the expedition leader. He held the camera for me and I got the clip.

When I returned to the ship, I got grave looks from the other passengers. My face was tomato red. By the next morning, my skin felt like wax paper. It was dry and dead and unbearably itchy. Each time I scratched it, long strips would peel off. I removed my entire face and washed it down the sink, leaving me with a swollen, scabby Halloween mask.

I hid in my cabin for the whole trip home, afraid to walk the halls out of fear I'd be mistaken for a zombie.

I paid a high price for getting that dancing clip. My face fell off, but it did grow back, eventually.

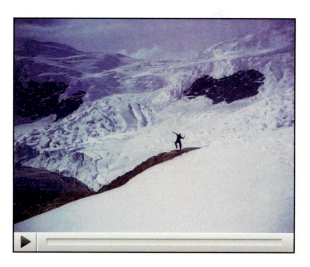

Tikal, Guatemala

There is only one hotel servicing visits to the ruins of Yaxha and Nakun. It's called El Sombrero and it's off the main road to El Remate. Depending on how you read the guidebook, it's either two hundred meters off the road or seven miles.

I got the bus driver to dump Melissa and me at the turn-off. We started walking. Turns out it was seven miles.

Melissa and I had been together for two years by that point, but this was our first time traveling together. One minute we were cruising toward Tikal, the next we were stranded in the middle of nowhere, and I suddenly seemed to be enjoying myself. It was starting to get dark and we had no Guatemalan currency left. My deviation from our solid, reliable plan was so effortless and swift, it appeared to her like sabotage.

I laid out all our options and Melissa chose to stay with our luggage while I went into town to try and get us a ride to El Sombrero.

I found a little roadside shop nearby and asked the owner in broken Spanish if the village

had a taxi. Actually, I may have asked her if I could buy a taxi—not sure. She eventually got the picture.

She said there were no taxis, but she took me to her father. He said something along the lines of: "I will drive you to that weird hotel out in the middle of nowhere that no one ever goes to for ten U.S. dollars, but I can't leave for an hour. You can wait here or you can wait back at the turn-off. I don't care."

I went back to the turn-off and found Melissa waiting with a couple of local men who were trying to talk to her.

One of them asked if she'd ever studied Spanish.

She said yes.

He asked how long.

She said, "*Siete . . . um . . .*"

He said, "*Siete días?*"

She said no, and then failed, after seven years of studying Spanish, to remember the word for "years."

I presented Melissa with the fruits of my labor.

"So a strange man who isn't a cab driver is going to pick us up by the side of the road in maybe about an hour and take us to some hotel in the jungle that may or may not be open for business?"

"Well, when you put it like that . . ."

It all worked out fine in the end. We soon found ourselves in a jungle cabin on the edge of a lake filled with crocodiles. Aside from a small staff, we were the only people for miles.

That night, I woke to the sound of a UFO descending over our roof. Numerous cackling aliens poured out of the ship and surrounded us. They discussed their method of penetrating our cabin through a series of echoing hoots and howls. I let Melissa sleep to spare her from the trauma of our abduction.

In the morning, I learned we'd actually been visited by howler monkeys.

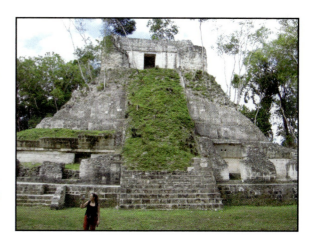

We went to Nakun and found that the ancient city's excavation had barely even begun. Many of the ruins were treacherous; not much more than loose rocks and dry roots with some footholds kicked in.

Dear Melissa's mom,

I kind of accidentally almost killed your daughter while we were climbing down this path. She was below me when I placed my foot on what looked like a large, sturdy rock. It ripped loose and fell. I was so focused on what each of my other limbs was doing that I failed to notice. Melissa's spider-sense tingled and she slid to one side as the rock plummeted past her. So, ultimately, no harm done. But still . . . sorry about that.

Many of the ruins at Yaxha were similarly unspoiled. There were dozens of mounds concealing temples and dwellings that have remained buried for centuries.

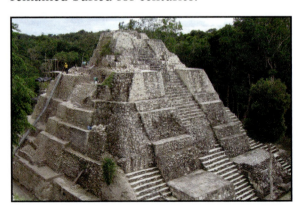

That night, we got a ride to El Remate. We bought cheap whiskey in town and wandered through a field of lightning bugs to our secluded cabin, where we laid on hammocks and got drunk.

We had arranged to go to Tikal in the morning, but it meant we had to wake up at 3:30 a.m. to catch the van.

In the dead of night, we walked by headlamp along the hotel's footpath toward the road where the van was to meet us. A flicker on the ground reflected back the light from my head. I stopped. The flicker moved sideways.

I stepped closer and realized what I was staring down at.

"Don't move! Tarantula."

"What? Where?

"Right in front of us. On the ground."

"Where!?"

My headlamp was reflecting off its eyes. That's how big it was. We were making eye contact.

"It's looking at me."

We were both, the spider and I, frozen with terror.

Melissa, being slightly to my side, couldn't see the headlamp's reflection in its eyes. All

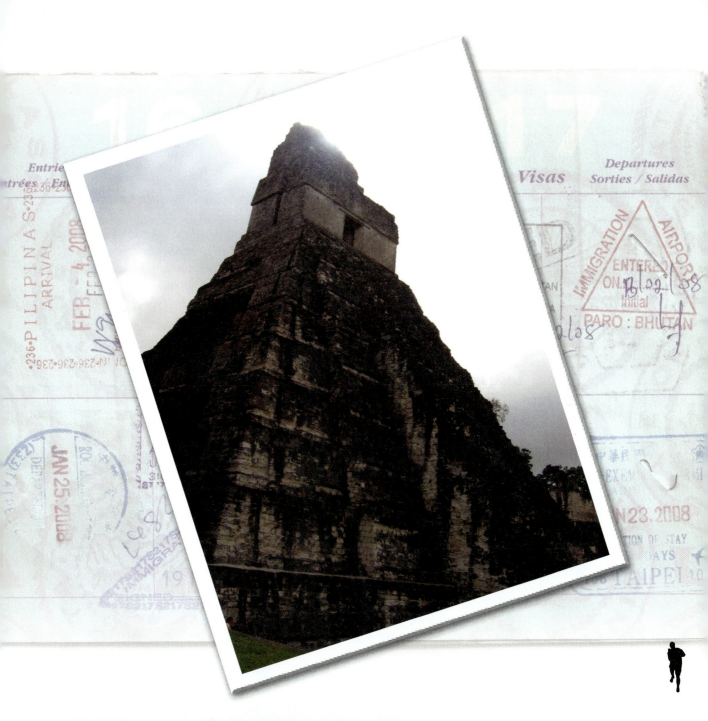

she could see was blackness, and somewhere inside that blackness she knew there was a giant tarantula.

I am hysterically arachnophobic, by the way. The main reason I'd resisted traveling to South and Central America up to that point was specifically to avoid the situation I had suddenly found myself in.

In my mind, the tarantula had every intention of crawling down my throat and laying eggs in my stomach. In reality, it moved cautiously to one side while I moved cautiously to the other. I led Melissa forward and the three of us crossed paths without incident.

Upon reaching the road, I remained on vigilant spider-watch duty until the van finally arrived.

This image of Tikal should be familiar to anyone with a healthy nerd background. It's the establishing shot of the rebel base at Yavin IV, from which the devastating attack on the first Death Star was launched. We saw this view once as the Millennium Falcon descended, and again in the Special Edition,

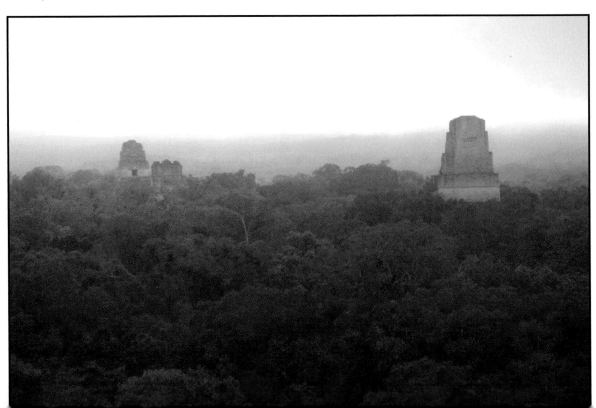

when squadrons red and blue emerged in their X-wings, followed closely by gold and silver squadrons in their outmoded, lumbering Y-wings.

. . . Sheltered childhood.

We arrived at the Grand Jaguar Temple at mid-day, just as the sun was cresting the peak of the structure. With the sun beating down and a groundskeeper mowing the lawn beside me, I danced.

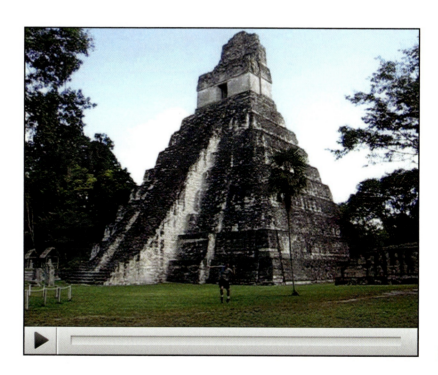

Galápagos Islands, Ecuador

In 1832, the nation of Ecuador sent a mass e-mail to all the other countries declaring ownership of the Galápagos Islands. The e-mail went directly into the spam folders of most countries it was sent to. The few that bothered reading it chuckled to themselves, as if Ecuador had just announced a successful bowel movement. One or two even sent sarcastic replies, congratulating Ecuador on its bold conquest of an uninhabited cluster of volcanic rocks.

Three years later, a guy named Chuck Darwin paid a visit. He wrote a book called *On the Origin of Species by Means of Natural Selection or Whatever*, which contained many of the observations he'd made on the islands. It was the kind of mental leap forward that happens, at best, once in a century. The book profoundly altered the way humans view them-

selves and everything around them, and sold almost as many copies as Dr. Phil's *Ultimate Weight Solution*.

Melissa and I planned our four-day catamaran tour with the goal of dancing near a Galápagos tortoise. We landed on the tiny island of Baltra; once an Ecuadorian naval station, now an entry port for hordes of marauding tourists. They piled everyone from our flight into a bus and took us to one of the only real towns on the islands: Puerto Ayora.

Something I didn't expect to find in the Galápagos: a castle-themed karaoke discothèque.

We got on our boat and met the other passengers; five elderly retired couples and a doctor from Long Island who brought his three teenaged children.

The next morning, we had our first landing. It was on the largest of the islands: Isabela. Isabela is essentially a string of volcanoes whose lava flows have fused together.

The Galápagos burst out of the water naked, four million years ago. Hawaii pulled a similar stunt some twenty million years earlier. The harsh lava rocks of Hawaii have had time to turn into white sandy beaches and lush forests, making it a tropical wonderland. The Galápagos is still in the early stages, making it a grim hellscape.

On the ride back to the archipelago, we got our first glimpse of marine iguanas basking in the morning sun.

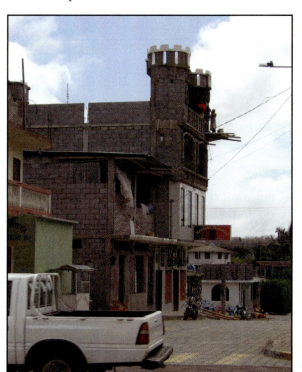

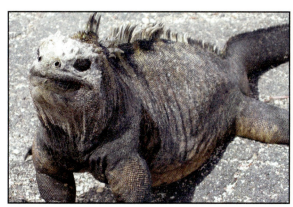

Darwin enjoyed goofing off with the iguanas. He writes in his journal:

"I watched for a long time until half its body was buried. I then walked up and pulled it by the tail; at this it was greatly astonished, and soon shuffled off to see what was the matter; and then stared at me in the face, as much as to say, 'What made you pull my tail?'"

We went snorkeling and were joined by a pair of sea lions.

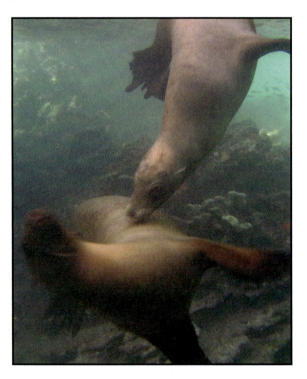

They followed us on our way, sneaking up from behind, zipping around us in circles, performing acrobatic feats for no particular reason other than to amuse themselves and, perhaps, us.

On the way to our final destination of San Cristobal Island, a pod of a hundred dolphins joined us to perform somersaults in our wake. While that was going on, a Galápagos shark surfaced beside the boat. In the distance I saw a whale spout, then turning the other way, a manta ray breached fully out of the water. We were evidently passing over a massive seafood buffet and these giants of the sea were pigging out.

At dawn, the cruise was over and we realized we'd failed to accomplish the singular task that justified our visit: I came to dance with a giant Galápagos tortoise.

Galápagos tortoises are a beleaguered species. If any of the indigenous wildlife on the islands had been more menacing than a squirrel, the tortoises would have been preyed upon to extinction long ago. Darwin had a grand old time exploiting their total inability to defend themselves, as he writes:

"I frequently got on their backs, and then giving a few raps on the hinder part of their shells, they would rise up and walk away;—but I found it very difficult to keep my balance."

The Galápagos tortoise has been left vulnerable to the encroachment of human-introduced animals like feral goats, who graze on their foliage, and rats, who steal their eggs. Conservationists have mounted an effort to eliminate goats from the islands, picking them off with rifles from helicopters. It's kept the tortoises from being wiped out entirely—there are about 14,000 left—but they can clearly no longer survive without the constant assistance of humans, who made their lives so difficult in the first place.

We learned there are only a few places on the islands where Galápagos tortoises can still be viewed outside captivity. One of them is the tortoise sanctuary on San Cristobal Island where we were dumped off at the end of the cruise. Melissa and I tracked down a guy with a pickup truck and hired him to take us across to the far side of the island.

We happened to catch them at lunchtime. They munched on leaves and wandered around me as I danced in their midst. Mission accomplished.

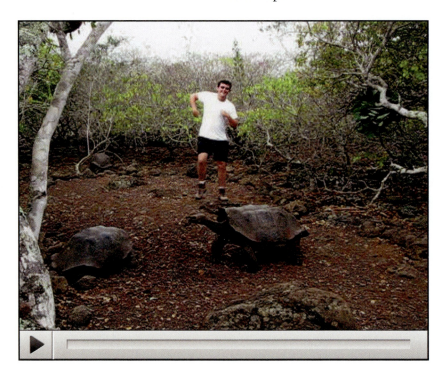

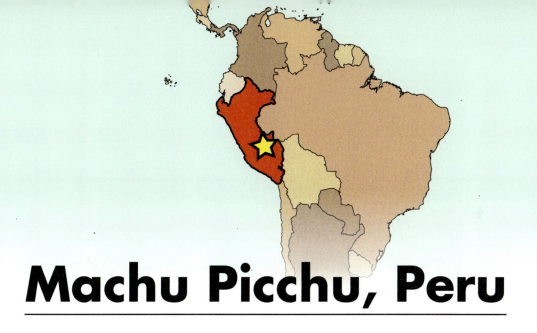

Machu Picchu, Peru

Machu Picchu Pueblo, formerly known as Aguas Calientes, is a boomtown providing access to the nearby ruins. It sprouted out of the Sacred Valley a few years ago and is growing faster than anyone seems able to govern.

It is not difficult, in Machu Picchu Pueblo, to find handbags with the words "Machu Picchu" sewn into them. It is also not difficult to find restaurants serving vegetarian pizza to dreadlocked college students. What is difficult is finding anything else.

We dropped our bags in a square, concrete slab of a room with a square, concrete bed that smelled like a combination of mold and fart. After settling in, we caught the next bus zigzagging up the valley to Machu Picchu proper.

When visiting sites like this, one is encouraged to hire a local guide who can provide a historical context. I eschew this option, preferring to figure things out for myself.

It may interest you to know that Machu Picchu was actually built by llamas. Anthropologists hide this information from the public and pretend it was the built by the Incas. They do this because they hate llamas. The anthropologist is the sworn enemy of the llama.

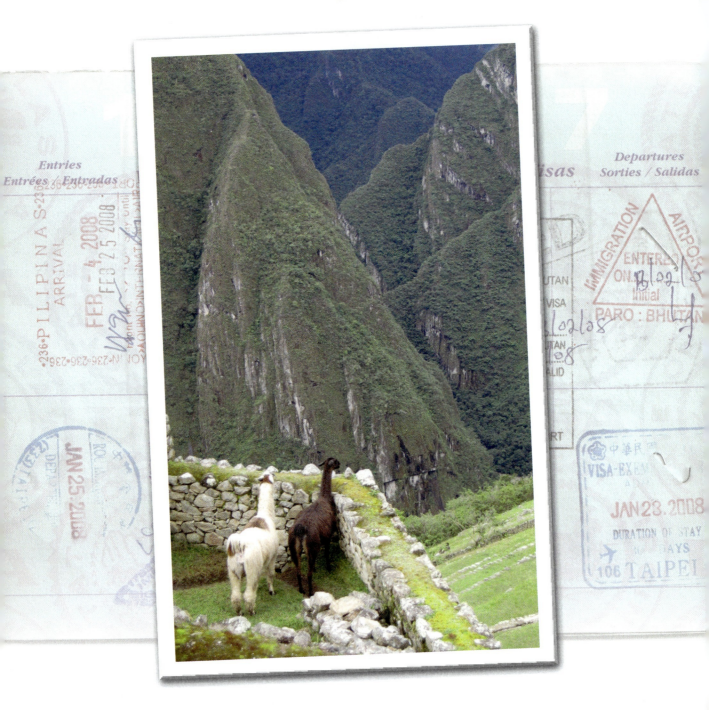

MACHU PICCHU, PERU

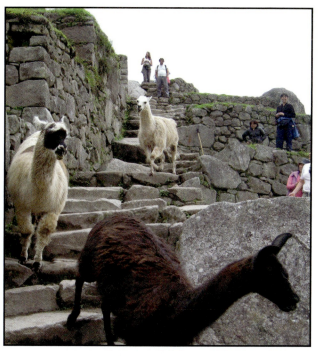

Llamas built Machu Picchu because it gave them access to the Great Chocolate Milk River that runs through the valley below.

There is nothing llamas love more than chocolate milk. They're crazy for it. Everyone knows this.

The chocolate milk from the Great Chocolate Milk River is incredibly tasty. This is because it moves very quickly and gets churned up in the rocks.

These days, llamas are oppressed by humans. We almost never let them drink chocolate milk. So whatever you do, don't bring chocolate milk to Machu Picchu. This will stir the llamas up and cause what is known as a "llamapede."

If you get caught in a llamapede, it's your own dumb fault. Don't say I didn't warn you.

When we arrived, the site was completely shrouded in fog, which dashed our hopes of a dancing clip. The sun eventually emerged and burned off the fog, but by then the site was shrouded once again—this time by Japanese tourists. In time, that too passed, and I was able to dance.

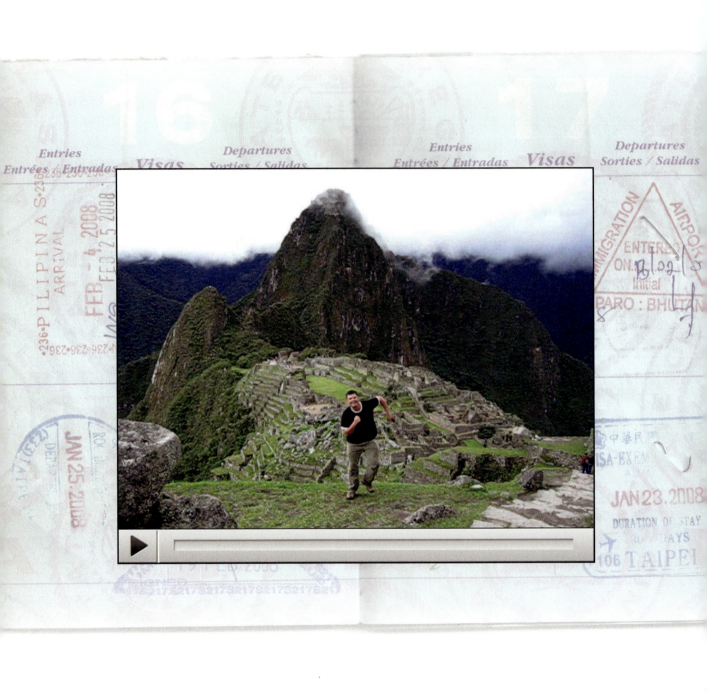

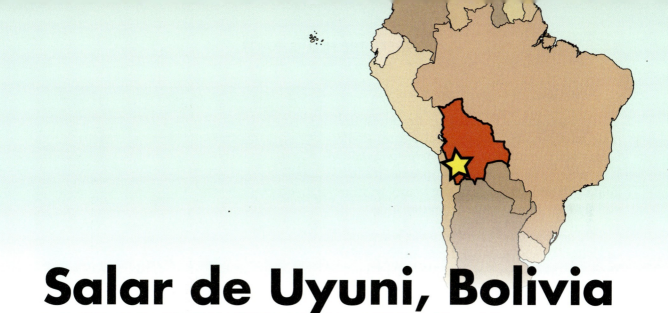

Salar de Uyuni, Bolivia

There is no oxygen in La Paz.

Call me crazy, but I'm obsessed with the stuff. I can't get enough of it. And at 3,500 meters above sea level, I'm simply not able to get my fix.

The city was founded by the Spanish inside a massive volcanic crater to serve as a rest stop on the trail from Lima to Rio. This unusual layout means its outlying neighborhoods climb the steep crater walls up to the rim on every side.

We visited the much-ballyhooed La Paz witchcraft market. There didn't seem to be much to ballyhoo about unless you get excited about mummified llama fetuses and inflated toads with bejeweled eye sockets.

We checked into the main hostel.

If I could take a minute here to address the male backpacker demographic: please, don't bring your guitar. It's not going to get you laid. It's not going to help you meet people. It's just going to annoy them. No one wants to hear you struggle through "Redemption Song."

We got up at dawn to make our way south to Uyuni. When we arrived, we hired a 4WD truck to take us out to see Salar de Uyuni: the world's largest salt flat. It's nine thousand square kilometers of perfect nothing.

In this part of the year, the rainy season leaves several inches of water on the ground, which reflects the full expanse of the sky as if it were a single, infinite sheet of glass.

The window views weren't quite doing it for us in the truck, so we crawled up onto the roof.

I don't believe I have ever, in my life, felt less like I was on planet earth.

Dancing was fairly painful, as I had decided against wearing shoes. The salt crystals are hard and sharp. I never managed to get more than five seconds of dancing without doubling over in pain. Fortunately, five seconds was all I needed.

The next day we hired another 4WD to continue southward toward the Chilean border. It was a twelve-hour drive, but it saved us a day and took us through some extremely remote territory—about as high into the Andes as anyone can go without an ice pick or a propeller.

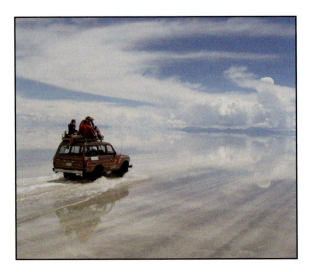

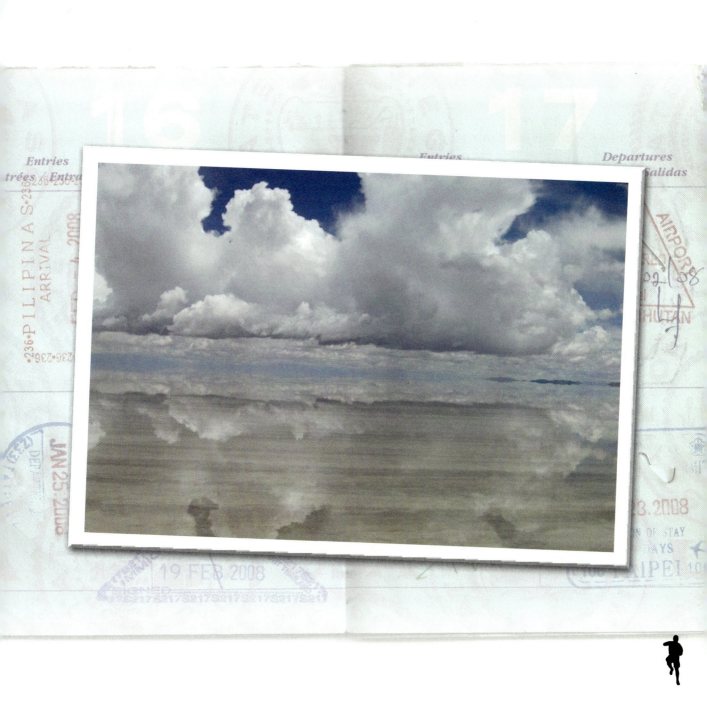

We stopped near the border to wait for a bus that would take us across to Chile. We shared our slice of barren wasteland with a young, English-speaking tour group. We talked to an Australian girl who was finishing up South America and then heading on to Oman. She drilled us on our travel plans, asking increasingly specific questions until we finally broke and, for the first time on our trip, told a stranger what we were doing.

"So, someone is paying you to travel around the world and dance wherever you want?"

" . . . Pretty much, yeah."

"You must be an amazing dancer."

"Actually, I'm really, really bad at it."

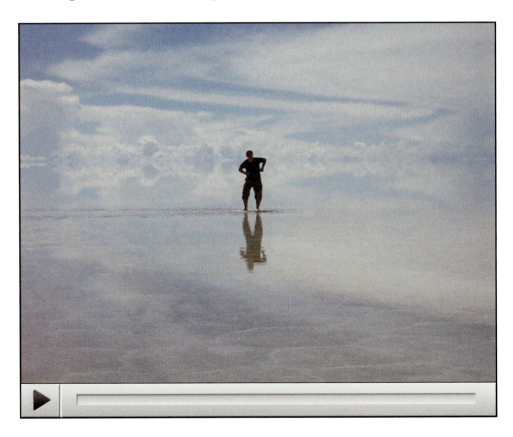

Easter Island, Chile

Flights to Easter Island are really expensive.

When people plan trips to South America, they might throw it in there initially. Giant stone heads in the middle of the ocean—who wouldn't want to check that out? Then they find out the price, and . . . hmm, maybe next time.

Melissa stayed in Santiago to explore the city, while I caught a flight to go dance with the *moai*. As the plane approached our destination, the in-flight display became an unblemished sheet of blue with only a single, tiny speck 3,700 kilometers off the coast of Chile. Easter Island is often called the most isolated island in the world.

It was named by Dutch explorers, who discovered it on Easter Sunday, 1722. No kidding. Some guy said, "Hey, look at all those stone heads. I've never seen anything like that in all the world. Now what should we call this place . . . ? Oh! I know! Today's Easter. Let's call it Easter Island!"

While we waited for our bags, a group of indigenous Rapa Nui men dressed in loincloths with ceremonial body paint performed a traditional dance to welcome us.

Standing next to me in the audience was a conspicuously solo traveler who was, like me, a decade or two younger than almost everyone else on the plane. His name was Dom.

Dom was from Nottingham, England—as in *The Sheriff of*. Dom had recently quit his thrilling job at a database company that tracked credit card debt and advised on loan approvals. He took his savings and spent it on a yearlong trip around the world, with no idea what he was going to do when he returned home, but a conviction that it had to be better than what he was doing before he left.

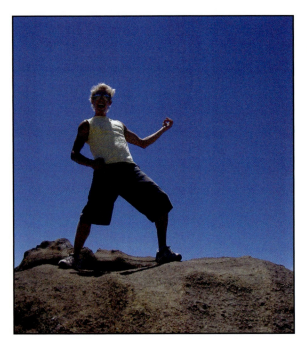

We were staying at the same guest house, so before going to bed, Dom and I went into Hanga Roa, the one and only town on the island, to get a drink and determine whether the other was a homicidal maniac. Also on the agenda was the awkward business of revealing my background as an Internet dancing sensation and recruiting him to be my cameraman.

I eased into the subject and it went smoothly. "You are the luckiest bastard I've ever met," he responded. "Of course I will hold your damn camera."

We rented a 4WD to tour the sites. Driving on Easter Island is loads of fun. It's basically one big, scenic, off-road racetrack.

I will now insert my spotty, hazily informed history of the Rapa Nui people.

So they land on this island, sometime, I-don't-know-when, coming from I-don't-know-where. At some point, the Rapa Nui got the idea to carve giant, stone heads, called *moai*, to represent, most likely, their fallen ancestors. The purpose of the *moai*, it is thought, was so the ancestors could watch over their kin groups.

They hauled these colossal lawn ornaments to the distant shores of the island to be set upon their *ahu* (giant stone platforms), employing ropes, pulleys, rolling logs, and

probably loads of other methods that you'd pretty much have to be stuck on an island all your life to dream up.

Then one day, the Rapa Nui started running out of everything. The trees had pretty much all been chopped down, probably in the service of moving *moai*, so they couldn't make any more boats to fish with. By that point, the population had swelled to over 15,000. There wasn't enough land to feed everyone through agriculture alone, so things started getting a little tense. Kin groups that had peaceably coexisted suddenly started killing each other off. And to add insult to injury, they began tipping over each other's *moai*.

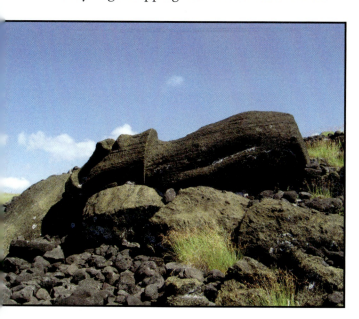

Anyway, at some point in the modern era, after European contact but before we'd really had an opportunity to screw things up, the Rapa Nui culture self-destructed on their own.

Dom and I circled the island until we came to Rano Raraku—which is very hard to say without sounding like Scooby-Doo. It's the site where volcanic rock was most abundant, so the heads were sculpted there before being transported all over the island. There are more unfinished heads in Rano Raraku today than there are all over the rest of the island.

The Rapa Nui invested all their hopes for salvation in their wacky obsession. It was obvious to them that they'd done something to piss off their ancestors, and the only way to fix things was to demonstrate a more intense level of worship and sacrifice.

. . . There's a lesson in there, somewhere, I'm sure.

I decided to shoot a dancing clip beside these *moai*, which are the most striking and probably the most photographed on the island.

A park officer was lurking nearby, and every time I tried to stand next to them she would appear and shoo me away. We circled around the hill to distract her, then, when she wasn't looking, we ran back and shot the clip.

Once I shot my clip, I was content to take a few pictures of the heads and move on, but Dom had his own agenda. He is a bold practitioner of the "comedy photo," and I was obliged to assist him in this.

Who am I to judge, really? I'm the dancing guy.

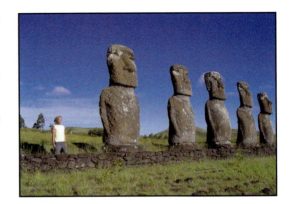

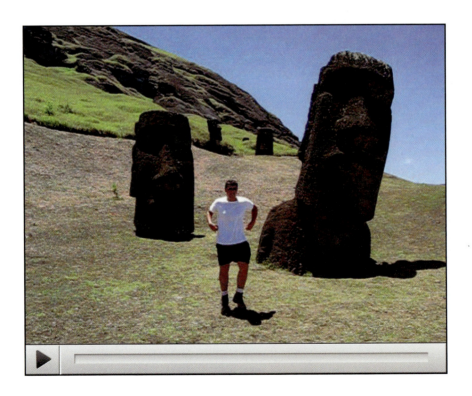

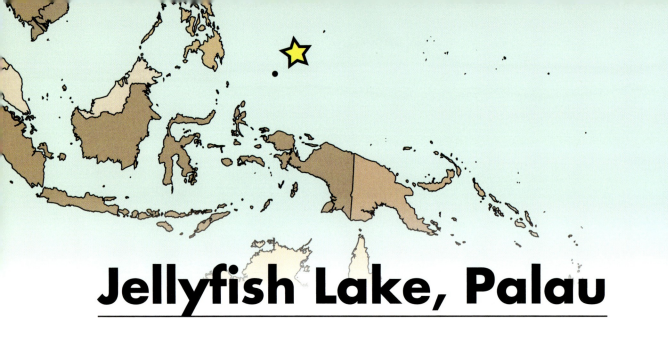

Jellyfish Lake, Palau

At some point, thousands of years ago, Jellyfish Lake became sealed off from the ocean that surrounded it. The jellyfish trapped inside were able to thrive on the algae that still grew in the lake, and they found themselves suddenly unburdened from any threat of predation. As a result, over the millennia that followed, they evolved to lose their ability to sting. They simply no longer needed it.

Today Jellyfish Lake is exactly what its name suggests, packed full with millions of the strange creatures. You can jump inside and no harm will come to you. It's like swimming through a giant

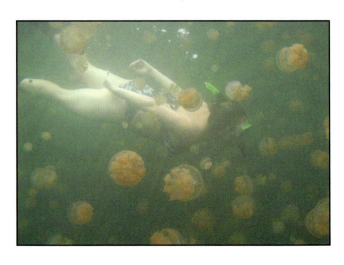

bowl of slimy breast implants. Just don't swim to the bottom and take a gulp. Any deeper than fifteen meters and you'll be drinking toxic levels of hydrogen sulfide: the chemical compound responsible for the smell of flatulence.

So don't do that.

Upon entering, Melissa and I soon found that our presence was much more harmful to the jellyfish than theirs was to us. Their tissue is so brittle that the slightest contact with a treading limb will cut them in half. It's virtually impossible to swim in the lake without perpetrating a massive slaughter.

In hindsight, I'm not sure we should have been allowed in the lake. I'm not sure anyone should. It's too precious and unique to endure our oafish flailing. But we were already there and . . . well, we were already there.

I'd brought a plastic housing for my digital camera, so shooting underwater was possible, but a little tricky. Between the housing and Melissa's dive mask, she couldn't get her eye in place to look through the viewfinder

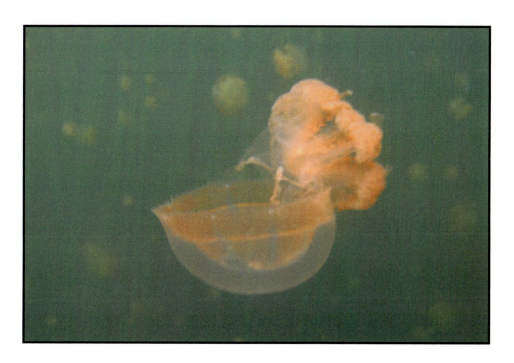

while she shot. She just had to point it in a direction and hope. We also learned that you can't really call out "action!" underwater, so it was kind of hard to know when to start dancing and when to stop.

Dancing underwater is *hard*.

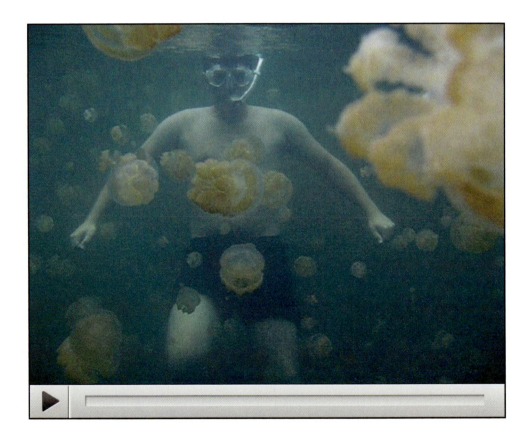

Chuuk, Micronesia

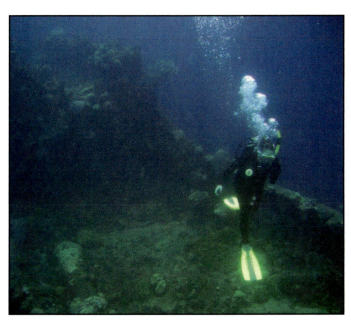

We fell backward into the water and dropped slowly into the Pacific Ocean. I watched Melissa sink down past me, and beyond her, the outline of a shipwreck came into view: the *Sankasan Maru*.

We followed our Chuukese guide, Gerard, into the interior of the ship, down a corridor, and into a small room. We panned our flashlights and saw crusty medical equipment strewn across the floor. A surgical table lay in the corner, a stack of human femur bones piled on top of it.

In February of 1944, much of the Japanese naval fleet was stationed off Chuuk Island (then known as Truk, because German colonists couldn't make the "ch" sound) when the United States launched Operation Hailstone: a massive air and surface attack that sank over sixty ships inside the lagoon. Today, the wrecks still house the remains of thousands of Japanese sailors killed during the battle.

Unable to communicate verbally, Melissa and I exchanged stunned glances, then continued on through the corridor and out to the ship's stern.

The old steel hull was covered in bright coral and teeming with fish. A gray reef shark circled below us off the side of the ship.

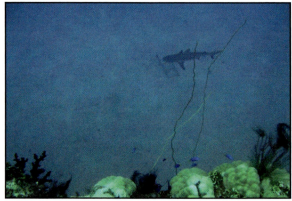

Gerard tapped his knife against his tank to attract the shark's attention. I signaled that it was unnecessary. We didn't need a closer look.

Our second dive took us into the Fujikawa Maru; an aircraft transport. It had just delivered thirty disassembled bombers when it was struck amidship by an aerial torpedo.

It sank in a shallow part of the lagoon, making it one of the most accessible of all the wrecks. We reached the forward hold. I watched Gerard descend between the beams into the ship's dark belly.

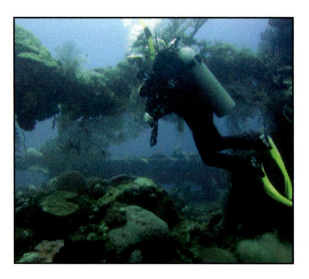

The floor of the first hold was overrun with debris. I hovered in place and absorbed the finer details of the room, feeling strangely like I'd swum into an Iron Maiden album cover.

Gerard led us through to the next hold. We emerged over the remains of a zero fighter plane.

We swam up into the crew's living quarters. The main corridor ended in an eerily lit stairway leading up through the heart of the ship to the bridge.

We entered another hold. Its floor was covered in sake bottles; many of them still full. Gerard picked one up, pulled the cap off, and let the sixty-year-old fermented alcohol float to the surface.

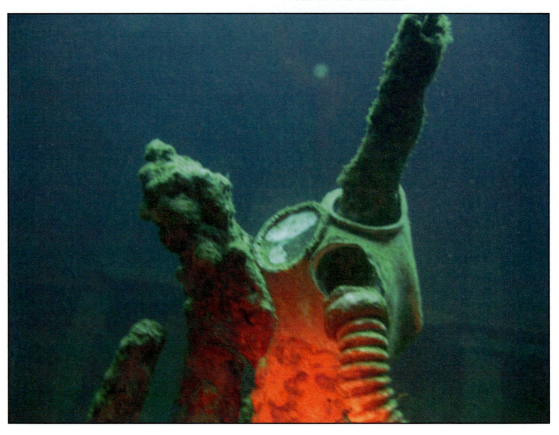

Out on the deck, Melissa and I got in position to shoot a dancing clip. I removed my fins and placed them behind a head of coral.

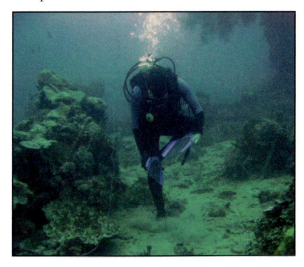

Once they were off, I realized I was almost totally incapable of moving myself anywhere. Melissa, meanwhile, had the opposite problem. Every time she tried to focus on the camera controls, she found herself drifting toward the surface.

We finally got set up for the first take, which we immediately realized was the only one we'd be able to shoot. My dancing kicked up so much sand and muck that I was enveloped in a thick brown cloud. Visibility was ruined.

As I mentioned previously, dancing underwater is hard.

Melissa tapped my arm and held up her gauge to show me she was low on air. Fussing over the shot had caused us both to lose focus on our breathing, and we had only minutes left to surface from a depth of over a hundred feet.

We ascended to just beneath the dive boat and leveled off for our safety stop. By then Melissa's gauge was down to 300 psi—dangerously below the minimum level.

I could've shared my regulator with her. I also could've grabbed one of the spare tanks dangling in the water next to us for precisely that situation. Instead, I panicked and did neither. I took us straight to the surface without completing our safety stop, putting both of us at risk of decompression sickness.

We were both awestruck by our experience. I'd obsessed about wreck diving for years, but Melissa confessed she never understood the fascination.

"There was no way I could have known," she said. "I get it now."

We returned to the hotel and relived the details over dinner. But back in our room, something changed. Melissa's emotions from the low-air incident, and from what we'd seen inside the wreck, came out in a tangled knot. She was spooked.

I told her I understood. Essentially, we'd just entered a haunted house . . . buried in the ocean floor . . . surrounded by sharks.

Melissa sat up that whole night. I'd never known her to back down from anything out of fear, but something in the water stuck with her and she couldn't shake it. By dawn, she'd decided she was done diving for the trip. There wasn't much I could say. She borrowed some comics and waved us off at the dock.

At 510 feet, the Heian Maru is the largest ship in the lagoon, but when I looked down from the surface, all I could see was the flat ocean floor. As I dropped down, I realized I wasn't looking at the ocean floor at all. The Heian sunk on its port side. I was looking at the vast expanse of the ship itself.

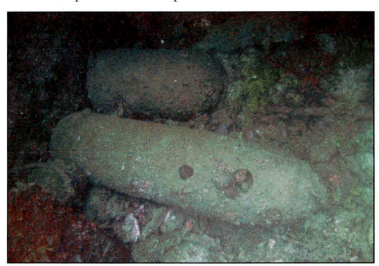

We stopped at a small coral bommie growing on the hull. Gerard grabbed a stick and thrust it into a hole not bigger than his fist. He swirled the stick around as if dueling with some unseen opponent. Suddenly, a geyser of black smoke poured out from the hole and blinded me. I saw something shoot past, and I saw Gerard reach out. When the smoke cleared, Gerard had his hands cupped together as eight tentacles squeezed out from between his fingers and wrapped themselves around his arm.

Gerard held onto the octopus until it calmed down a bit, then passed it over. It clung to my forearm and stared up at me, assessing, then spoke in a mild, Liverpudlian brogue. "Welcome to my garden, friend. Stick around. Enjoy the shade. But tell the other one to knock it off with that stick nonsense?"

There are a few live munitions still dormant inside the wrecks.

Gerard pointed to one, then made an explosion gesture with his hands and signaled to stay clear.

Got it. Don't touch.

The ship's two rear propellers were my last, best hope for a clip.

The wrecks of Chuuk are filled with breathtaking sights, but I couldn't really dance in front of most of them. I could get adequate light on the ship's exterior and the propellers were sufficiently gigantic.

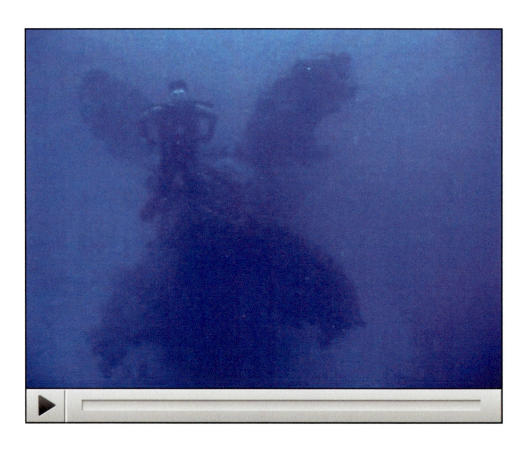

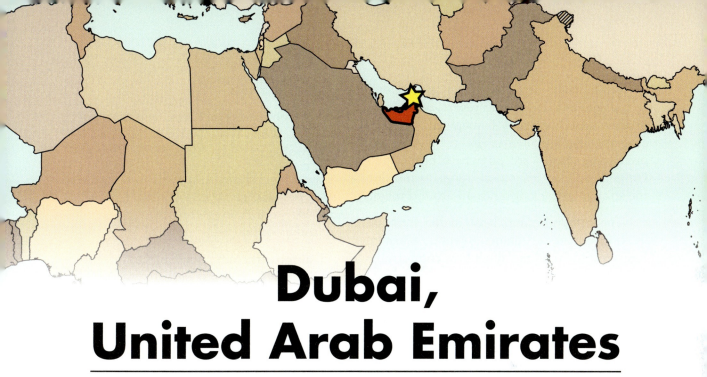

Dubai, United Arab Emirates

I stopped in Seattle long enough to say hi to my family, do some laundry, and run a few errands, then it was back on a plane for the second half of the trip.

I left Melissa behind. She could only sign on for three months and then it was time to get back to real life.

I arrived in Dubai for an extended stopover on my way to Africa. The entire city was under construction in the spring of 2006. It was clearly a work in progress. There were only three kinds of accommodation available. I couldn't afford to stay in the luxury hotels, so I tried to get a room at the ones offering long-term housing for migrant laborers. They were all full, so I was stuck with the next tier down: hotels used primarily for prostitution.

I needed sleep. I got a room and ignored the noises.

While in the city, I took the opportunity to visit the new indoor ski resort, which was exactly as ludicrous as I imagined. Western ex-pats enjoyed themselves on the slope, pretending they were anywhere other than Dubai, while locals stood agog, examining the strange white substance all around them.

The next morning, I sat in the terminal looking out at the planes; Qantas, Garuda, Emirates; and thinking about how comfortable I'd become in airports. I could go anywhere, I realized, because I was nowhere. I had only what I could carry, and that was enough.

I was in transit.

And for as long as I remained that way, I felt okay. When I stopped moving, that was when problems caught up with me.

But then I thought: *airports are soulless, antiseptic, and generic. Why am I at peace here? Why am I only happy when I'm on my way somewhere?*

I suppose the next question is fairly obvious. But it had only just occurred to me:

What am I running from?

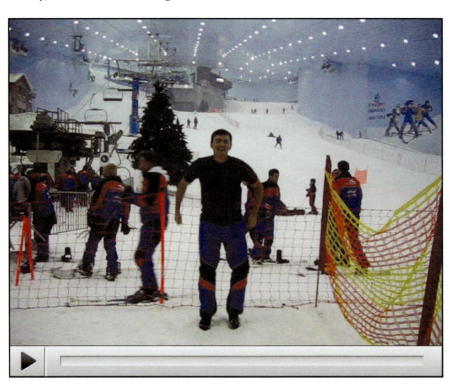

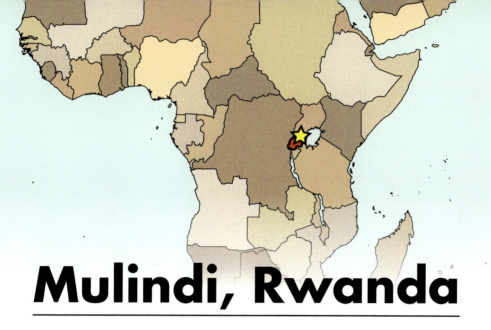

Mulindi, Rwanda

My round-the-world itinerary didn't leave a lot of room for improvisation. I stuck close to my plan, deviating only when circumstance or weird intuition demanded it. Rwanda fell into the latter category.

My friend, George, happened to be there as I was passing through the region. He worked for Grameen Foundation, a non-profit that links telecom companies to microfinance organizations, enabling women in rural villages to borrow money so they can purchase "village phone kits." Literally a business in a box, the kit included a mobile phone and antenna. Use of the phone could be sold to other villagers, giving them vital access to the outside world. Meeting up with George offered me a way to get around the countryside and into places that would otherwise be much more difficult to access.

I unwittingly arrived in Rwanda in the middle of Hope Week: an annual remembrance of the 1994 genocide that resulted in half a million deaths. The impact of such an event is beyond reckoning. I visited the mass graves. I listened to the stories. It left me with a tremendous feeling of numbness. My tools of comprehension were inadequate.

I rerouted myself to Rwanda because there was something I wanted to express with the video beyond just dancing in front of famous landmarks. I knew, from my prior visit to Africa, that laughter and joy were not difficult to come across. Even in places of great need that should be overcome with despair—especially in those places—there can be a pervasive openness and irreverence. As I jetted across the planet, I began to understand on an unconscious level that the many static wonders I had the privilege of visiting could not compare to the even greater wonder of human vitality.

I asked George to take me to a small village outside the capital. He drove us out to Mulindi.

George and I got out of the jeep with my camera at the ready. We were an immediate spectacle, which created a sense of urgency. We both knew that in a matter of minutes, things would get too weird.

I approached a group of kids who were playing together and greeted them, which used up all the Kinyarwanda I knew. They responded with playful curiosity. I broke into the dance. Within seconds, the first of them joined in with me, as if by reflex.

I stopped to show them what George had recorded. At that, more kids rocketed in from places unknown.

Take two was less guarded, and our numbers continued to grow. By take three, what seemed like the entire village had gathered around in a semicircle to see what was going on.

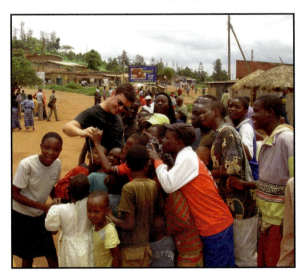

In the space of maybe three minutes, something beautiful had happened. George and I kept smiling. We showed off the footage we'd shot, thanked everyone who joined in, then waved goodbye.

It was the first time I'd ever done anything like that. I would struggle over the virtue of it for a long time, and to some extent I continue to. I came in and I took something from those kids. I used their performances without compensation and I benefited enormously from their inclusion in the video. Finding a way to repay them without causing hysteria would have been difficult, which is not to say I shouldn't have tried.

I was driven to get that clip because I wanted to show another side to a place that's usually only spoken of when addressing the horrors that occurred there. I believe it's important that those stories and images come out, but when faced with so much loss and suffering, there's a tendency to dehumanize the subjects in our perception. Maybe it helps us cope, or maybe it just helps us to dismiss. But to see the joy on their faces, and to witness a fuller spectrum of emotion, reminds us that they are no different.

I had stumbled upon a new twist to my project—a new way of doing things. It would take time for the implications to gel, and in any case it was too late to shift focus for the video I was working on, but I was beginning to realize that dancing in front of exotic backgrounds was a thin gimmick. I'd found what I should've been doing all along.

I should have been dancing with other people.

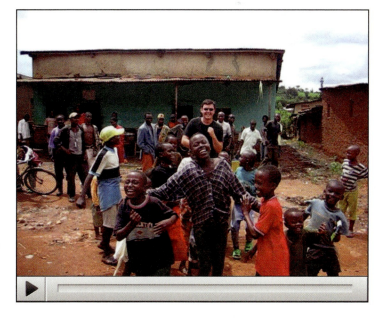

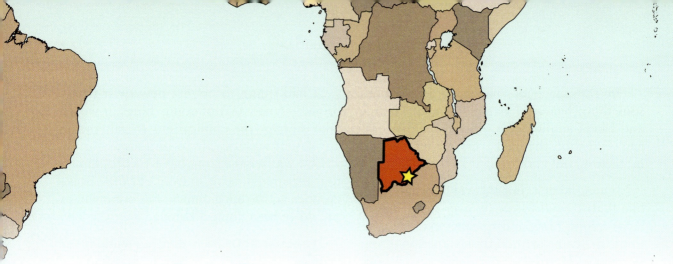

Mokolodi, Botswana

"Hello, sir. I came here to dance with your elephants."

If only it were that easy.

I was riding with Mr. Uttum Koria; a Sri Lankan man who ran an accounting firm in the capital city of Gaborone, Botswana. He was the owner of three African elephants that he rescued from Kruger National Park in South Africa. He was taking me to see them.

"In the nineties, they were culling the elephants in the park."

"Culling?"

"Yes. They were shooting them. They had too many. Also, they were selling the meat. In Sri Lanka, elephants are very important to our culture. We take care of them. I could not let this happen without doing something, so I adopted three of the orphaned young and brought them to my home here in Botswana."

"You kept them at home?"

"Yes, well, on our farm. It was quite a challenge. Asian elephants can be trained. African elephants are wilder—less docile. You can only do so much to control them. I brought three workers down from Sri Lanka to help raise them. We had to teach the elephants how to do things. These men are like their parents."

"How did you feed the elephants?"

"With great difficulty. As they grew larger, it became very expensive. I reached an agreement with this game reserve, Mokolodi, and donated the elephants to the park. Now they can roam more freely, but my men still keep an eye on them."

I'd arrived at Mokolodi the day before, asking if I could arrange a private visit with the elephants. They offered a vehicular tour, but said it would not be possible to get up close to them. I persisted, and eventually they deferred to Mr. Koria.

Mr. Koria was understandably skeptical of my intentions. Try explaining the dancing videos over the phone. It loses something. He'd had bad experiences with documentary crews who rarely offered anything in the way of compensation.

"Taking care of these animals is very expensive," he said.

Fortunately, I had chewing gum money for just these occasions.

Mr. Koria took the following afternoon off work to escort me. He did the same a couple years earlier for another visitor from the states named George W. Bush. The forty-third U.S. president spent a day in Botswana, which included a brief visit with these uniquely people-friendly African elephants.

"It was a bit stressful. The secret service had marksmen on all the surrounding hilltops with rifles aimed at the elephants in case they should charge."

"Would bullets have stopped them?"

"I don't think so, no. Not quickly enough to save anyone in their path. But I did not tell them that."

We reached the caretakers. Mr. Koria took me over to the elephants and showed me how to interact with them.

"Take your time. Let them get used to you. Try not to make any sudden movements."

"Uh, that last one may be a problem."

When the elephants seemed comfortable enough with me, I handed Mr. Koria my camera and started dancing with my back to them. We shot two clips. During the second one, the eldest male got a bit edgy and made

that trumpet sound elephants make in cartoons. The noise sent me dashing away. I've since learned it's the elephants warning that it is about to trample you.

"Yes, I think we are finished now. It is good that you ran. Discretion is the better part of valor."

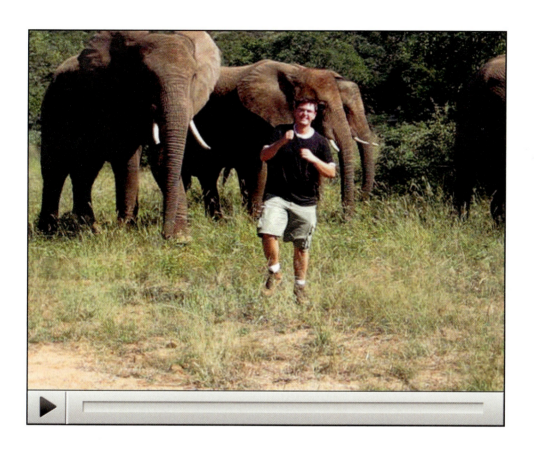

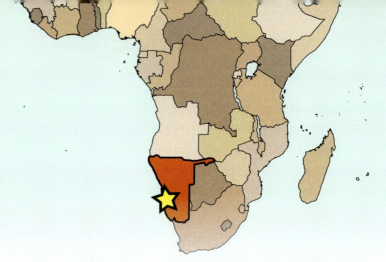

Sossusvlei, Namibia

I blew my first tire on the road to the Sossusvlei desert.

While I was fixing it, Chris and Joe, two guys from Philadelphia, pulled over to check on me. If I'd lost another tire, I'd have been screwed, so they kindly followed behind me the rest of the way to the park in case I had any more trouble.

We went into the desert together the next morning. We visited Dead Vlei, where a cluster of camel thorn trees once grew. They lost all their moisture a thousand years ago, but remain standing, sun-scorched and unable to decompose in the dry air.

We climbed the tallest sand dunes in the world and walked along their ridge lines.

Chris and Joe were both avid photographers, and relished the job of composing shots for me.

When a storm hit, our hair stood on end, and it dawned on us that we were human lightning rods. We raced back to our cars in abject terror.

We went our separate ways after that. I passed a newsstand while stopping for gas and learned, much to my surprise, that Brad and Angelina were in Namibia as well, preparing for the birth of their experiment in optimal bone structure. I passed their resort while driving up the coast between Walvisbaai and Swakopmund. A photo of their offspring was said to be worth $5 million, but I had better things to do.

I entered the Skeleton Coast desert, named for the many shipwrecks strewn about like bathtub toys around a drain. In the days before the outboard motor, it was impossible to launch a boat from the shore, so once the powerful tide brought vessels in, they were stranded. To make matters worse, the desert stretches inland for more than a hundred kilometers, leaving sailors with little chance for survival.

I hoped for a better fate when I turned inland and ventured toward the vast emptiness alone.

The weather from Sossusvlei followed me, and I was hit by torrential rain after sundown. When it rains in the desert, rivers form quickly out of nowhere. I found myself fording through flash floods in my two-wheel-drive Toyota Tazz, hoping against hope that my remaining tires would hold out.

They didn't.

I pulled to the side of the road, fifty kilometers from the coastal town of Hentiesbaai and just as far from the settlement of Uis up ahead. I grabbed my bags and waited for another vehicle.

A German woman passed by in a pickup

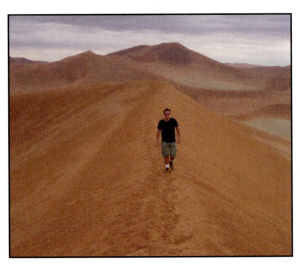

truck and brought me back to Hentiesbaai. I got a room at the tavern and ventured out the next morning in search of a spare tire. I paid Frank, a refugee from Zimbabwe, to help me carry my brand new tire to the side of the road, then drew up a sign that read: FLAT TIRE ON ROAD TO UIS

I sat on my tire and waited three hours for a ride. Finally someone stopped. It was a man named Leonard, driving a beat-up old Isuzu packed to the brim with his wife, seven kids, and all their belongings. We settled on a price, and I squeezed into the back of the car.

Half an hour into the drive, we approached a man walking along the side of the road, barefoot, with no food or drink. He had a shirt tied over his head and he was drenched in sweat. He didn't seem to notice us as we passed. Leonard took a look at the guy and decided against stopping to help.

We drove on, and I watched the Phantom Stranger disappear into the horizon behind us. Soon after, the Isuzu made a strangled coughing sound and sputtered out.

"No problem," Leonard said. "I am a mechanic. I can fix it."

Leonard grabbed a screwdriver from his glove compartment. His family and I crawled out of the car and watched him go to work on his carburetor.

I took pictures of the kids to keep them entertained.

Leonard took a break for a family portrait.

After an hour went by, I looked back to see the Phantom Stranger emerge once again from the horizon and move toward us.

With each passing minute, it became more likely that we'd have to deal with the guy before we got moving. I felt a growing sense of dread.

It may have been two hours before he arrived, possibly more. Leonard put his carbuerator down and joined me with his family behind us. He greeted the Phantom Stranger in Afrikaans. The Phantom Stranger replied, and even I knew what he said was mostly gibberish.

Leonard whispered to me, "This man, he is not right in his head."

"Yeah. What do we do?"

"Keep your eyes on him. I am almost finished."

Leonard went back to work. The Phantom Stranger sat down near the vehicle and continued watching us, mumbling to himself the whole while.

I'm not sure what Leonard did to get his car running, but I'm certain at one point I saw him use his snot as a lubricant. His wife kept trying the engine, and at last it came back to life. We piled inside and left the Phantom Stranger behind.

A short ways further, we reached my car. Leonard helped me replace the badly damaged tire.

And I was back on the road.

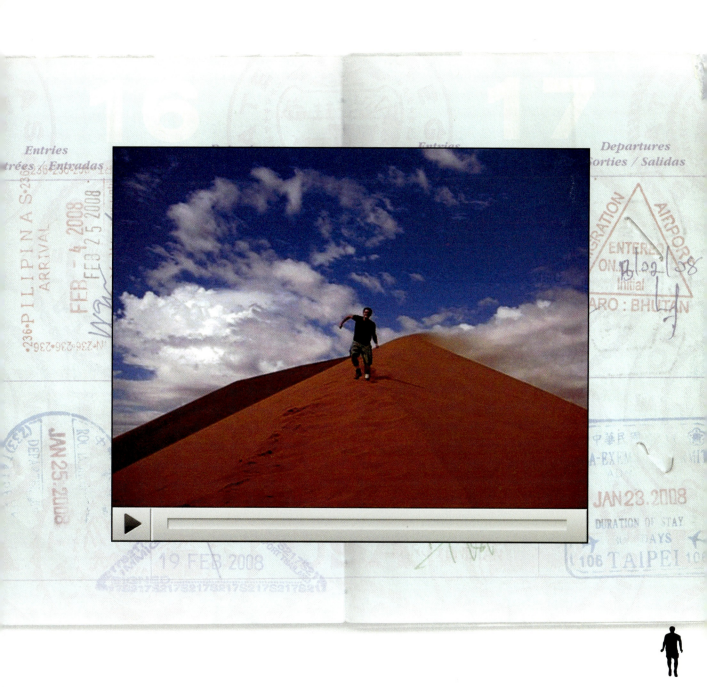

Abu Simbel, Egypt

My visit to the Giza pyramids was stymied by ridiculously early closing hours—why would anyone want to watch the sun set over the pyramids, anyway? I couldn't get the shot I wanted, but I convinced the guards to hold the camera for me while I danced near the entrance, then had dinner across the street at a traditional Egyptian eating establishment.

I decided the pyramids were a bit too postcard-perfect, so I didn't bother going back. Instead, I gambled my time on a last minute flight down to Abu Simbel.

Abu Simbel was built three thousand years ago by Ramses II. Well, he didn't actually build it. I think he hired contractors. It was placed along the banks of the Nile

near the Nubian border—now Sudan—mostly to scare the crap out of anyone heading downstream.

The colossi guarding the entrance are all depictions of Ramses II himself, which makes me think the planning meeting must have gone something like this:

One colossus isn't scary enough. There should be four. The first one should be me. The second one also should be me. The third one, I don't know, I'm thinking me. And the last, well, if it was anyone else it'd just look weird, right?

The enormous size of the figures is striking from any distance, at any angle. As a child of Nintendo, I can't help but imagine them rising to battle in defense of whatever power ring or medallion is kept inside.

The inside of the temple is almost, but not quite as impressive as the outside. It has eight more giant sentinels standing guard—and guess who they depict. The walls are covered in elaborate murals and hieroglyphics. Alas, no power rings. No medallions.

Such things were probably removed in the sixties, when the entire structure had to be urgently relocated to higher ground. Turns out some geniuses decided to build a dam nearby. It was going to raise the water level dramatically, *as tends to happen*, and Abu Simbel

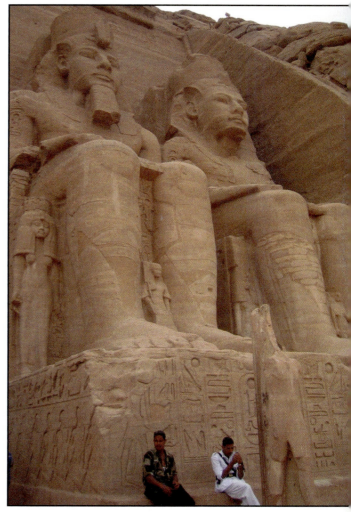

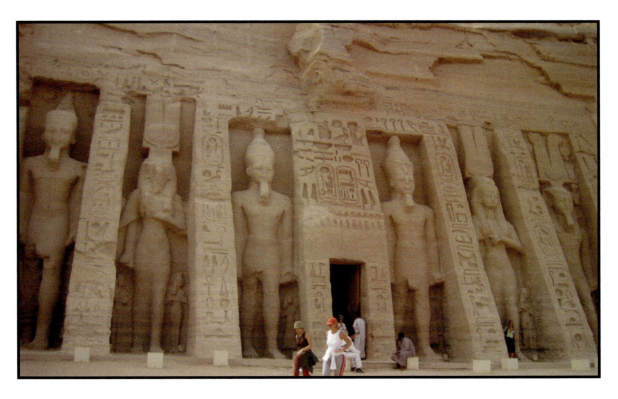

would have been submerged along with several other ancient sites if the UN hadn't come in with millions of dollars, loads of construction equipment, and some common sense. An artificial cliffside had to be made to house the façade, which gives the whole place an even more jarring resemblance to a movie set.

The next-door Temple of Hathor would be impressive if it were located anywhere on the planet *other* than where it is.

It has six standing figures at the entrance, not quite as tall as the other guys. Ramses showed a little bit of humility on this one; only four of the figures are him. The other two are his wife . . . well, one of his two hundred wives, anyway.

That had to have ticked off the other 199.

I retreated from the heat to my hotel, walking distance from the site and built for large tour groups. I relaxed by the pool and

used the bathtub and complimentary soap to do laundry for the first time since Botswana.

The morning after my arrival, I woke at 5 a.m. The colossi face the rising sun, so I wanted to see if anything fancy happened. You know, like pointing the way to hidden treasure. I also figured it'd be a good chance to dance without so many people around.

The only other folks with the same idea were a Japanese tour group. They stared in silence at the horizon and applauded when the sun peeked out. The sun replied bashfully, first dimming itself slightly and then returning behind the mountains to wait for them to leave.

I got a young Japanese guy named Satoshi to hold the camera for me. He turned out to be traveling on his own and had nothing to do with the massive tour group.

I danced with Ramses, Ramses, Ramses, and a pair of dismembered legs that once belonged to Ramses.

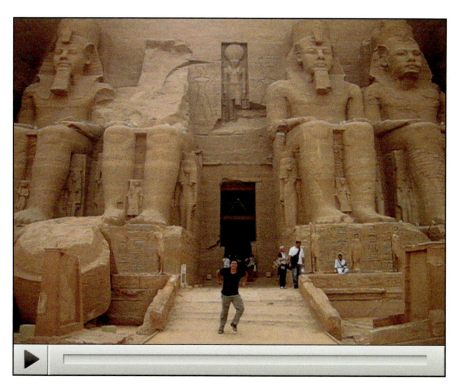

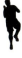

Ephesus, Turkey

I spent my first evening in Istanbul eating kebabs at a bustling café in the shadow of the Blue Mosque. It was filled with burly mustachioed men and women playing backgammon and smoking from *narghile* (hookah) pipes. It felt like part of some elaborate municipal effort to maintain tourist expectations. I had to tap one of them on the shoulder to make sure he wasn't animatronic.

I slept a lot in Istanbul. First, it was recovering from the 4 a.m. flight, but I eventually realized I was worn down by much more than that. Six continents down. One to go. I was perpetually disoriented, waking up each morning alone, not knowing what country I was in.

So many of the landmarks across Europe are holy religious sites. I've passed through quite a few shrines and temples on this trip so far, and I've noticed they all tend to say the same thing: "Look how much we love God!" I can't say I'm all that impressed at this point. I'm not sure God is, either.

Hey, wow, Sistine Chapel. That's fantastic, guys. No, really. I'm speechless—totally flat-

tered. Tell me something, though . . . Have you seen the Grand Canyon? 'Cause I made that. How about Wadi Rum? Ngorongoro Crater? Uh-huh. That was me too. . . . Boy, love the tile work. And those frescos. Man, that must've taken you forever. This is definitely going on the fridge.

I checked out the famous Grand Bazaar as a possible dancing location. It's an open market with over 4,500 shops. It sounded exciting until I got there and remembered I don't like shopping.

This packaging is somewhat alarming.

I decided to explore outside the city and found a bus headed for Troy. Yes, that Troy. Who knew it was in Turkey?

I fell asleep waiting for the bus to leave. When I woke, there was a guy sitting next to me. Xiao Wei grew up outside Shanghai. He lived in Germany studying chemistry and was traveling through Turkey by himself. I liked him instantly. We formed a fellowship.

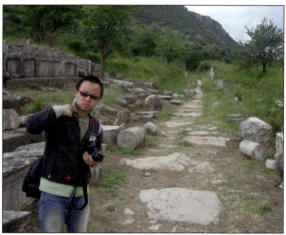

I showed Xiao my most recent cut of the new dancing video over lunch at the Troy souvenir complex. I'd been editing it on the road for the last couple weeks. He watched in silence, as if I were showing him my driver's license. He said it would be a nice thing to have ten years from now. I suppose it will.

EPHESUS, TURKEY

We took the overnight bus to the ancient Greek city of Ephesus. It was much more impressive than Troy.

We continued past the tourist throngs, eventually finding the quiet, somewhat haunting road to Ephesus.

I'll take a few haphazard chunks of column over the big spectacle if it means I can see it on my own, without any guides explaining how it was put together, breaking the spell, ruining the ruins.

Onward to the main attraction: the façade of the Celsus Library.

It had to be reassembled block by block from rubble—a couple thousand years of earthquakes left a lot of damage. I danced as construction workers toiled away.

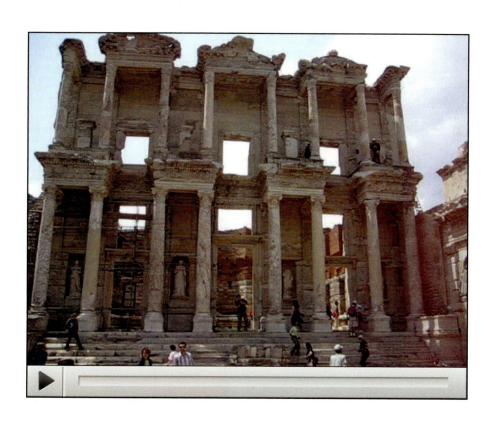

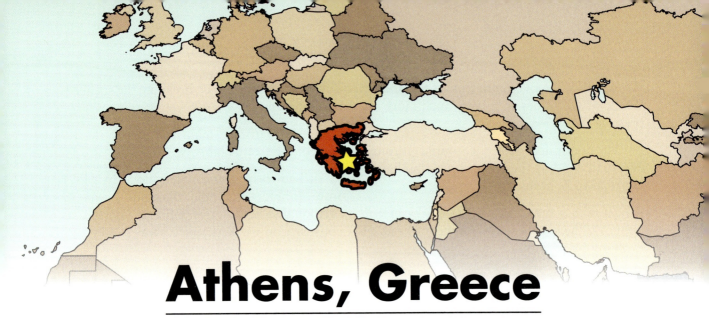

Athens, Greece

So I finally got arrested for dancing.

I woke up one morning on a ferryboat to the sound of a guy yelling at me like I was a vagrant.

Looking around, I saw an old guy blowing snot out of his nose on the floor next to me. I realized I *was* a vagrant. The ferry had come into port at Athens. Literally everyone but the old guy and me had disembarked while I slept.

It was 5 a.m. The sun was a long way from rising. I didn't even know where to tell a cab driver to take me. I wandered the streets for an hour until the first coffee shop opened, then loitered there until it was early enough to get a hotel room without paying for the previous night.

I slept for six hours. Waking in the afternoon, I set out on foot for the Parthenon.

I talked to some ancient Greeks.

"Where you from?"

"America."

"America? Too big."

"Okay. Um. How about Switzerland?"

"No. America is a big place. In what part do you live?"

"Oh. Seattle."

"I see. Seattle is very different from Alabama."

"Yes it is."

"*Fucking shit Alabama!*"

"Uh."

People often ask me if I have trouble traveling as an American. The answer is no. I generally get a positive response to stating my nationality—or at least the benefit of the doubt.

I continued walking up the hill.

As the dancing video goes, standing in front of ancient stuff is largely obligatory. There are places like Angkor Wat and Abu Simbel that leave me truly astonished. But the Taj Mahal? Pyramids? Parthenon? They're so overrun with visitors that they feel like products. By themselves, they're incredible, but the mystery is gone, and with it, my interest.

The sun went behind some clouds, so I sat down on the bench, pulled out my sudoku book, and I waited. A short guy in a black leather jacket sat next to me. He pulled out a scratchy AM receiver and blasted Greek talk radio.

The sun came back, and a couple Japanese guys were taking pictures of each other. I asked one of them to hold the camera while I danced.

"Ten seconds," I explained.

"Okay. No problem."

So I started to dance, and the guy in the leather jacket got up from the bench and stormed into the middle of the shot.

"What do you think you're doing?" he asked.

"I'm dancing."

"You can't do that here. You must delete it."

"You're joking, right?"

"Delete the picture right now!"

"I'm not going to delete anything."

The Japanese guy sensed trouble. "Ten seconds," he said. He handed back the camera and left.

"What you are doing is disrespectful."

"I don't think it's disrespectful."

"Give me the camera."

"I'm not going to give you the camera."

"Then take your things and come with me."

"I'm not going anywhere with you."

"Then I will call the police and you will go to jail."

"Who are you? Show me some identification."

"I will show you identification later. Come with me right now."

"I'm not going anywhere until you show me identification."

So the guy went and he got a security guard.

The guard said, "Show me the video." I showed him the video.

"You cannot do that here!"

"Why not?"

"It is against the rules."

"What rules?"

"Remove the video."

"Um. No."

"Then come with me."

The guard grabbed me by the arm and pulled me down the steps. *This is incredible*, I thought. *How far are they willing to go with this? How far am I willing to go with this?*

They took me to the front entrance and explained to the head guard what I was doing. The head guard pulled me down a path, around a corner, and behind a building, so no tourists could see.

"Listen to me. The Parthenon may mean nothing to you, but to us it is a *holy religious site!*"

"Oh really? And when's the last time you made sacrifice to Athena?"

"Give me the camera."

"I'm not giving you the camera."

"Give me your passport."

"I'm not giving you my passport."

"Then you will spend the night in jail."

"I've slept in worse places."

I held my hands out for cuffing.

He led me inside to what can vaguely be described as an interrogation room. Maybe it was just for lunch breaks, but in the moment it felt a lot like an interrogation room. He asked a couple more times for the camera. My response didn't change.

The guy in the leather jacket who started all this asked, "In your house, do you not have rules?"

"We don't have any rules against dancing, no."

"At your work. They do not have rules?"

"As far as I know, I've never worked anywhere with a 'No Dancing' policy."

"Why do you do this?"

"I'm traveling. I do it everywhere I go."

"And you do not think this is disrespectful?"

"I think it's *anything but* disrespectful."

"You are American, yes?"

Had to see that one coming.

A policeman walked in and asked what this was all about. They went through it all again. I was led out the gates to a squad car.

"What is it that you did?" the policeman asked.

"I danced."

"Show me."

So I danced for the cop. He shook his head. "You cannot do this here. Delete the film and you can leave."

"Nope."

And into the car I went. We got to the police station. They took me up the elevator and sat me down with the guy in charge.

He asked me all the same questions. I gave him all the same answers.

"Show me this video."

I played the Parthenon clip and a few others that were still on my camera.

Again I was asked, "Why do you do this?"

"It's a memento."

"Memento?"

"A souvenir."

He didn't get it. A young female officer who spoke better English translated for him. I noticed there were now eight officers surrounding me, all very interested in our discussion.

I suddenly wanted very badly to leave that place, and it struck me that I couldn't. I was being "held for questioning."

The chief yelled in Greek at the cop who brought me in. The tone was along the lines of "Why are you wasting my time with this shit?"

A little more yelling and the chief asked for my passport. This time, I gave it up.

One of the officers sat down with me. I could see him cracking a smile. "We're going to let you go." He winked at me discreetly. "We just need to take down your information."

I got up to leave. The guy in the leather jacket, still standing by my side and clearly a little embarrassed, tried to justify himself. "In other countries, the policies are maybe more . . . elastic . . . but here, you must not do these things."

The police chief asked one more time, "Will you delete this video?"

"I'm sorry. I can't do that."

"Okay. Get out of here."

I'd always considered myself to be fairly spineless. I was surprised to learn I could withstand a little intimidation when the matter was sufficiently absurd.

I don't know how I would've held up if there'd been anything serious at stake, like life or liberty. This was about the pursuit of happiness, which trails a distant third.

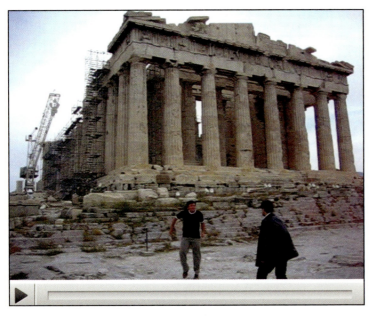

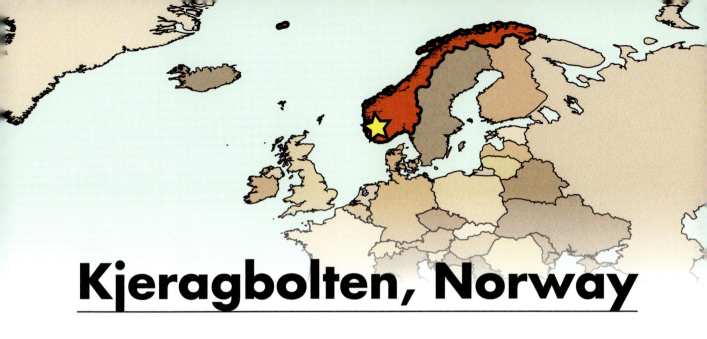

Kjeragbolten, Norway

At some point during the last ice age, the Kjeragbolten rock became wedged between the two faces of a chasm some one thousand meters above the water in the fjords of Norway. There is nothing man-made holding it in place. It just got stuck.

Several millennia later, I was e-mailed a photo of the place. I knew I had to dance there.

I was traveling through Europe at the time with a friend from Australia, also named Matt. Our itineraries overlapped, so I offered a deal wherein I'd pay for his hotels and transportation if he'd serve as my cameraman.

The photo of the Kjeragbolten came from a friend of a friend named Joachim. I hadn't planned to stop in Norway, but the image was too good to pass up. Joachim offered to let us stay with him and take us to the Kjeragbolten himself, so we chucked the itinerary, rerouted through Denmark, and took a ferry across the Skagerrak strait separating the North and Baltic seas.

We met Joachim in his hometown of Stavanger, then drove up into the fjords. The three of us hiked for several hours through late May snow.

We reached the cliff face looking down into the water more than a half mile below, then continued along its edge.

The instant I saw the rock firsthand, a wave of new considerations flooded my brain.

Before that moment, I was driven exclusively by a desire to get the shot. I simply hadn't contemplated the risk involved. In person, it was more than just a cool image; it was an exotically ridiculous way to get myself killed.

There is no net under the Kjeragbolten. There is a considerable amount of wind channeled into the chasm. And it was snowing, so the Kjeragbolten's curved surface was wet and slippery.

I'd been traveling for six months by that point. I was only a few days from flying home. The project had taken on great meaning to me. I believed the universe, or some unspecified entity sitting at its controls, wanted the video to happen, and was keeping an eye on me at least until I got the job done.

I believed the universe wanted me out there on that rock.

There's a thin ledge to the left that allows relatively easy access. As I stood there trying to screw up the courage to make the leap, Matt held the camera and quietly pondered the moral dilemma of whether to tilt the camera down if I should fall.

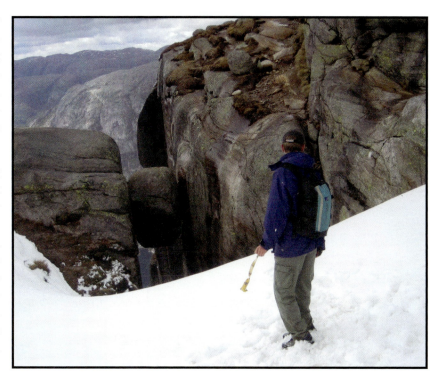

"Hey!" Matt called out to me.

"What?!"

"... Nevermind!"

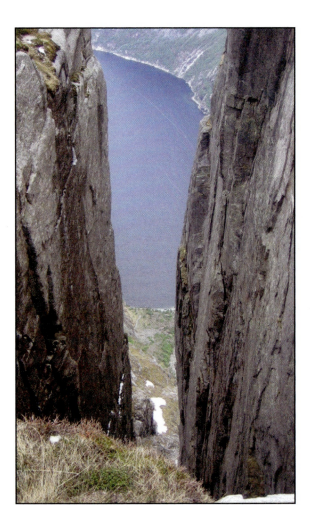

"No, what?!"

"What do you want me to do if...uh...?!"

"I'm trying not to think about that at this particular moment. Do whatever you think is best!"

"... Okay!"

And then I jumped. I have terrible balance, but the adrenaline kept me upright.

"You rolling?!"

"Go!"

I did a subdued version of the dance for ten seconds and then leapt back to solid ground.

I get queasy just thinking about it.

Dancing on the Kjeragbolten is the most dangerous thing I've ever done. It set a bar for stupidity that I never intend to exceed. But if I hadn't done it, it wouldn't be the same video, and I wouldn't quite be the same person.

On the long walk back to the car, I was fixated on that notion of being protected.

If the universe wants the dancing video made, what will happen to me once it gets it?

I don't want to be finished.

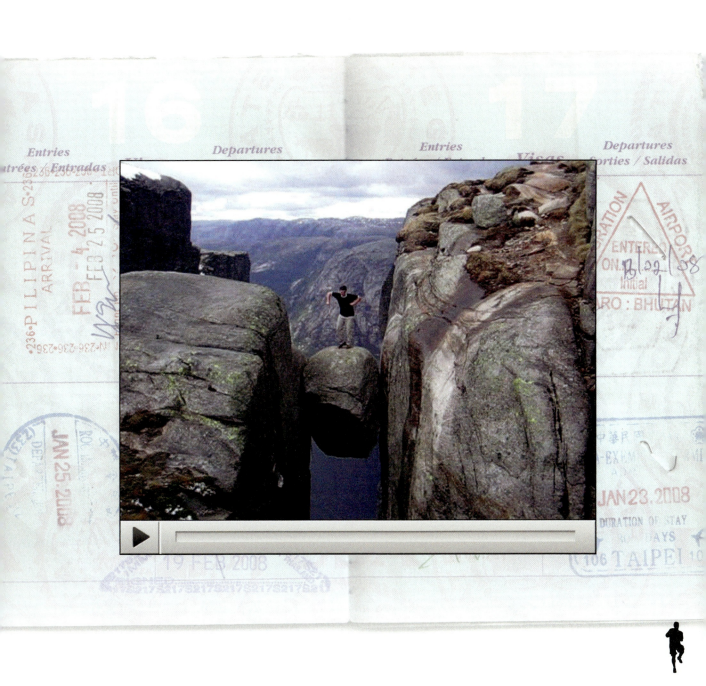

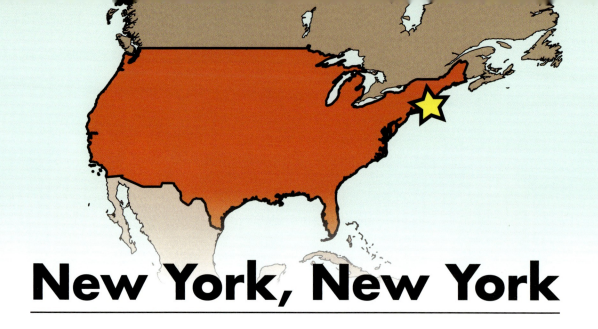

New York, New York

I was on a transoceanic flight from London to New York: the seventy-fifth and penultimate flight of this project.

Virgin. Business class.

My kind benefactors at Stride gum provided the flight to get me into town a day earlier than originally planned. *Good Morning America* had invited me on to mark the end of my trip and show a preview of the new video.

My laptop was crammed full of dancing footage. I had but to dust it off and assemble it into something presentable.

I was, at that moment, transitioning from unwashed, penny-scraping backpacker into pampered media anomaly.

A flight attendant gave me a relaxation kit with a sleeping mask, toothbrush, and socks.

Nineteen days ago, I was being kicked awake by a port officer on the floor of a Greek ferryboat.

My seat had a built-in inflatable back cushion. It folded into a bed.

Thirty-nine days ago, I was stranded in the Skeleton Coast desert with a broken down Isuzu, a spare tire, and a family of nine.

I ordered a spring herb salad with Scottish Loch Fyne salmon, smoke roasted in a hot kiln and then lightly chilled to give an oak-smoked flavor.

Fifty days ago, I was covering my head with a pillow to dampen the noises of a Dubai brothel.

The "flight therapist" came by offering back and scalp massages while a stewardess took my order from the bar.

You get the idea.

The word is: adaptable.

The next morning I was in the limo on the way to the *Good Morning America* studio in Times Square. It was a six-block walk from my hotel, but the show doesn't take any chances.

"So what's your thing?" the driver asked.

"I'm going to dance in Times Square."

"You some kind of professional dancer?"

"Not really, no."

After a quick meeting in the greenroom with a small entourage of Stride gum market-

ing and PR folks, I was asked to dance my way back from commercial, and then I was moved into position for a quick interview with Charlie Gibson and Diane Sawyer.

These things happen.

The next day, I dragged Stacy, a friend from Connecticut, to the Brooklyn Bridge. We ate bad hot dogs from a street vendor and I tried to keep mine down while I danced.

One nice thing about New York City: truly, no one cares at all. Shuffling on the wooden walkway, I was just one more bit of white noise.

Part Three:
Once More Around

I came back home to Seattle wanting to sleep for weeks, but there were only days left until I had to put the video up and I still had no idea what to do about music. I wanted to reuse the vocals from the "Sweet Lullaby" song, but with a new arrangement.

I called a composer named Garry Schyman who I met when I was working in videogames. He created a fantastic score for *Destroy All Humans!*, and he also happened to be the only musician I knew, so I asked if he might consider helping me out. Garry didn't quite know what to make of my strange project. He planned to say no, but his wife convinced him to give it a shot.

Garry wrote the new music in a couple days and sent me a demo using synthesized instruments. I wasn't thrilled with how it sounded, but he convinced me it'd come to life in the recording. At that point we didn't really have any other options.

I flew down to Los Angeles and watched Garry and his musicians create the song in a day. They pulled it out of thin air right in front of me and it was perfect.

When I started the trip at the end of 2005, YouTube was a fledgling startup delivering user-made video on demand. By the time I came back the following summer, it was at the center of a revolution in mass communication. YouTube offered a unique service and users ran with the idea, turning the site into a depot for any sort of footage worth looking for.

I finished up the second dancing video and uploaded it onto YouTube at the height of the site's burgeoning popularity. A million people watched the video over the first weekend. Within days, that number doubled. I was quickly swept up in a storm much larger and more intense than what I'd experienced before.

When my first video hit in 2005, it gradually expanded out from heavy Internet users to casual Internet users and eventually to the sleepy, out-of-touch mainstream media. By mid-2006, the media had caught on. Every talk show seemed to have a staffer assigned to tracking down the latest "viral video" sensation. Local news shows regularly ended

their broadcasts with some strange piece of footage they'd found on YouTube. To them, inviting me on as a guest was an amusing and reliable way to fill time. And so I did a whole lot of interviews: radio, television, newspapers, high school projects—whatever anyone wanted. I made it a point to be generous with my time, and I tried not to distinguish between big and small audiences. If someone was interested in speaking with me, who was I to say "no"?

I also left my e-mail address on my site and read every single message that came in: heartfelt missives from people around the world explaining what the video meant to them, and begging me to include them in a follow-up. I felt burdened by an implicit sense of expectation, and I agonized over the knowledge that I couldn't possibly live up to what those people thought of me. I had created an idealized persona in this carefree dancing guy who travels around the world with a big, goofy grin, and he was a far cry from who I really am.

As the weeks and months went by, I rarely left my apartment. I made enough money from the video that I didn't need to work for a while, so I returned to a life in which I had few obligations. Lying alone in bed with my laptop, obsessing over my Internet success shifted me off any kind of day/night cycle.

While I was in Africa, Melissa and I had broken up. Even though she remained an important part of my life, we were no longer partners. I had lost her support and grounding influence. I became untethered.

Melissa, meanwhile, had gone through a transformation. On the trip, she'd gotten used to constant change. When she came home, it was easy. She learned the benefits of taking risks and doing the *scary thing*. She found a new job that she loved. She bought a house. She even quit smoking. By the time I finished the trip, she was living a bigger life. She had remade herself into the person she wanted to be.

We navigated the dangerous waters of friendship and got to know each other as the people we'd become rather than who we once were.

All my life, I felt a need to be alone. Travel had finally given me that. I found I'd learned what I needed to learn, and now I was done. I was done being alone.

After six months apart, Melissa and I agreed to start over.

Getting back together with Melissa helped to stabilize me. Because she knew me so well and understood who I really was, it felt okay that I wasn't who so many others wanted me to be.

I came to see it like this: There's this guy who dances around the world. I happen to look a great deal like him, but he isn't real. He is an aspect of me. I don't have to pretend to be that guy all the time, but I found that I was perfectly happy to continue playing the part for all the happiness it brought to others and the extraordinary opportunities it brought to me.

I eventually started filtering the interview requests that came in. Most of them boiled down to the same five questions:

How did you come up with the idea?

Did you plan this?

How do you make a living?

What's your favorite place?

Can I come with you?

I'm at peace with the fact that I'll be answering those questions for a very long time, but I've also come to realize that none of my answers are particularly interesting or illuminating. The videos speak for me better than I can.

I still struggle to unburden myself from a sense of obligation to those who write to me with requests. The Internet leaves us all very open to others, and ultimately I think that's a good thing. But I learned how vital it was for me to define boundaries—to insulate myself from what others wanted me to do so I could focus on what *I* wanted to do.

. . . Hey, yeah, speaking of which: what *did* I want to do anyway? How does one follow up dancing around the world for a chewing gum company?

I remembered Rwanda: dancing with the kids, how joyful and spontaneous that moment was. I wanted to use the concept I'd established to say something big that seemed worth saying. An idea took shape for a new video that wouldn't just be about places. It would be about people. I would get them to dance with me in every place I visited.

By the end of the year, Melissa and I were hatching a plan to make another video. I knew this one was going to be a lot more complicated to put together, and it would involve organizational skills that far surpassed my own. Melissa asked me how we were going to make it work. Her contract job was about to end, and by state law, she couldn't go back to it for at least three months. I told her I was hiring her to produce the video and she was going to spend those three months traveling with me.

"I am?"

"Yup."

"And it's going to be my job this time?"

"Yup."

"Oh. I'll have to think about that."

"Take your time."

"I thought about it. Yes."

We took the plan to Stride gum. They seemed pretty happy with how the last one turned out, so they said "sure." And we were off.

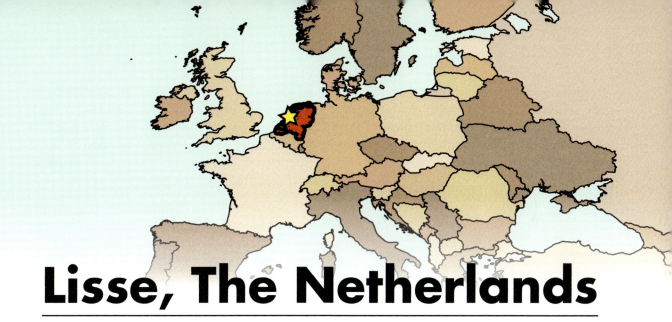

Lisse, The Netherlands

Part threes are tricky.

With part twos, you're saying, "Hey, part one worked out pretty well. I'm going to do it again and see if folks are still interested."

With part threes, you're saying, "I think I've really got something here. I can keep doing this over and over and people won't get tired of it." And of course, that's when things tend to fall apart. It's fairly reliable that most ideas will run their course by the second regurgitation. And a concept as sparse as mine certainly runs that risk.

The dancing videos weren't conceived as a trilogy. Of course, they weren't really *conceived* at all. But it felt to me like there was one more worth doing.

Preparing for a long trip abroad is always difficult. When it comes time to put your regular life into hibernation, there are a thousand little tasks to take care of, and I have a feeble man-brain that can't hold more than two thoughts at a time. For every new task that pops into my head, one of the old ones falls out the back.

Packing was equally stressful. I spread my gear across the living room floor and spent a whole day staring at it, putzing around for a little bit, then more staring, putzing, staring again, putzing, more staring.

After a full night of this, we were ready to leave for the first leg: criss-crossing Africa in about a month. My plan was to go on six separate trips, one to each continent, over the course of fourteen months. I would hit more destinations in total, but with a less grueling timeline that would allow me to maintain my sanity.

While stocking up on puzzle books at the airport newsstand, I spotted a Stride gum display in front of the register.

Well, hello there, sponsor!

Since the last video, Stride gum had started showing up everywhere. It seemed to be doing well, and every time I spotted a pack at the checkout counter I was reminded of my absurdly good fortune. I brought to mind jungle ruins, Antarctic vistas, and dolphin pods leaping from the sea.

We landed in Amsterdam early in the morning—an extended stopover on the way to Africa. A train and a groggy bus ride took us to the Keukenhof Gardens, which were in full bloom at the height of tulip season. The massive fields were divided into strips of red and purple and yellow and pink.

They looked so pristine and beautiful; it felt criminal to run in amongst them and dance. In fact, it very well may have been. But after mustering my courage, I endured the stink eyes of other visitors and ran in there to shoot the first clip of the new video.

Sorry, tulips.

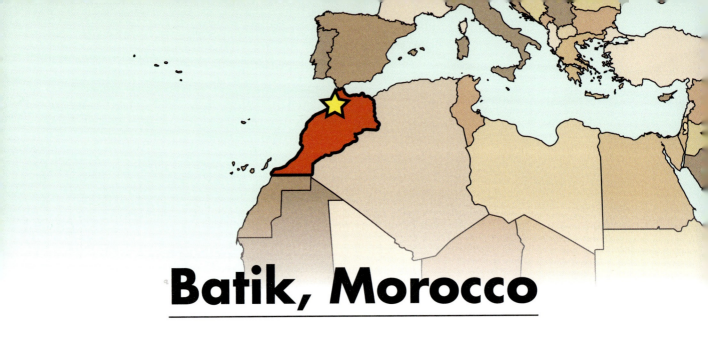

Batik, Morocco

Melissa and I landed in Casablanca. Our bags did not.

While I sorted out our luggage situation, Melissa waited with James, our British guide. James had some other friends from the U.K. staying with him and they knew all about *Where the Hell Is Matt*, so he'd already gotten an earful. I got the airport personnel to send our bags along, once they found them, in the direction James would be taking us: a town called Ouazazate (pronounced like *Whass-is-zat?*). It was a risky plan, but time was short and we couldn't afford to wait around.

We hopped in the 4x4 and drove from Casablanca to Marrakech on what James called the "most dangerous road in the world." Sucker that I am for world's-most-anythings, I was intrigued.

James said six thousand people die every year on the road between Morocco's two main cities. The road quality is actually quite good, but the problem is no one in Morocco actually has to learn how to drive in order to get a license. They operate on the principle of *Inshallah*, or "Will of Allah," meaning if Allah wants them to survive driving into oncoming traffic to pass other vehicles, he'll make sure they survive. There are loads of countries that operate

similarly, but most of them don't have highways as straight, roads as flat, enforcement as weak, or cars as fast as Morocco's. Hence the statistic.

Over the course of the ride, James gave us a thorough and engaging introductory course in Moroccan culture, history, and politics. I was relieved to learn he's a good talker, since we had about thirty hours to go in the car with him.

Ouazazate is the center of the sizable film business in Morocco. The first film shot there was *Lawrence of Arabia*. There've been dozens more since, like *Gladiator*, *Syriana*, *Blackhawk Down*, and *Babel*. Morocco routinely doubles for the Middle East, the Himalayas, and pretty much anywhere in Africa. James talked about working close protection for Brad Pitt and Jake Gyllenhaal on the films they've shot here. He doesn't dish (Brad, Jake, your secrets are safe), but he had some stories.

James took us to the shop where he takes his celebrity guests.

I picked up a scimitar and examined it. The shop owner, anxiously watching our every move for a milkable sale, strolled over, unsheathed it from its scabbard and whispered, "This blade . . . eet has keeelled."

Melissa had trouble understanding why that was a good thing.

We reached Merzuga well after sundown. It marks the western edge of the Sahara desert proper. It's the location for the famous sunrise shot from *Larry of Arabia*, and it's the spot we'd targeted for the Morocco clip.

James strongly advised that we see it either at sunrise or sunset. Since we had missed sunset and couldn't afford to wait another day, it had to be sunrise. You can't build a road through sand dunes, and with neither tank nor helicopter handy, the only way to get out there is two hours on camelback. That meant we could either wake up at 4 a.m. and race out into the dunes before the sun came up, or we could wolf down a quick dinner, ride camels in the moonlight for two hours, and sleep amongst the dunes in a Bedouin tent.

We woke up the next morning in the Sahara desert—feet cold, wind howling, camels barking. We threw on some clothes and raced into the dunes to catch the sun peeking out over the horizon.

The dancing clip wasn't great. In fact, in spite of the scenery, nothing really leaped out as the perfect shot. We headed back to town a bit disappointed, but it was hard not to look on the bright side.

Partway through the journey, our camels' legs became incredibly long and spindly.

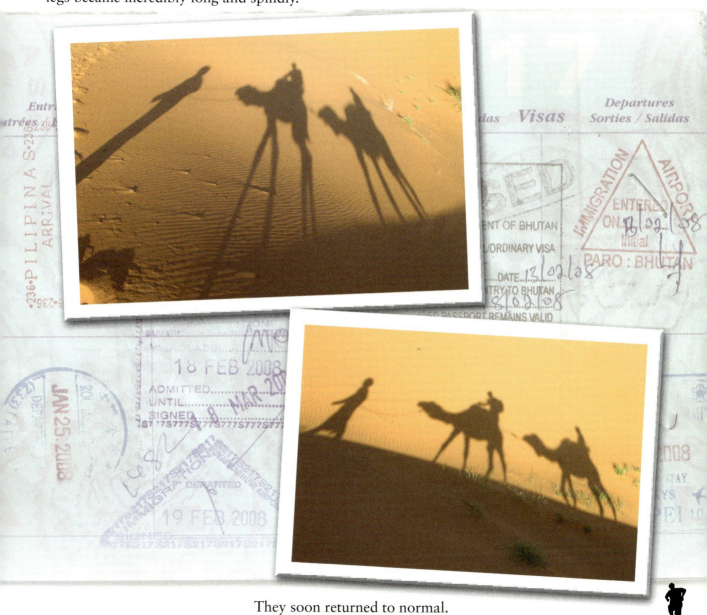

They soon returned to normal.

As we neared the hotel, Melissa crashed her camel.

Next, we went to Ait Ben Haddou: an old Kasbah city that's been restored to look as it did in ancient times for use in films.

We tried again to get the shot. Again, no. Kept driving. Stopped in Ouazazate. Our bags were there waiting for us. Some theft had occurred, but we were just glad to put some clean clothes on.

Nearing the start of the High Atlas Mountains, James made a wrong turn. We entered a town built over a fantastic set of ruins—broken remnants of high walls reaching up like spires over a low cliffside.

As we approached the ruins on foot, a band of children descended upon us. They followed us to the ruins and watched as I started dancing.

The kids found this puzzling. I invited them to join me. A few of them did.

Afterward, I faced a moral dilemma. The kids wanted money. If I'd simply ignored them from the get-go, there would have been no issue. But I'd invited them to join me, and they were fine dancers to boot. I decided to give them the change in my pocket, and to prevent the biggest kids from grabbing it all, I threw it up in the air.

It seemed smart at the time, but there was a sting of degradation. It felt wrong. Melissa, standing nearby through it all, got

a sudden and overwhelming dose of what Africa is like: so often, the best intentions turn out icky.

There was an undeniable commercial aspect to our endeavor. I was being paid to make something that would serve to promote a product. The word "exploitation" hovered over everything. I had to find a way to make things right with the participants. Throwing change at them would not do.

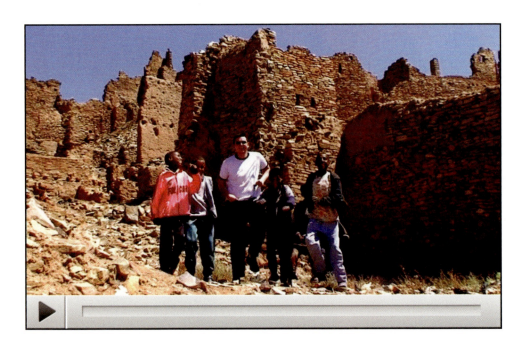

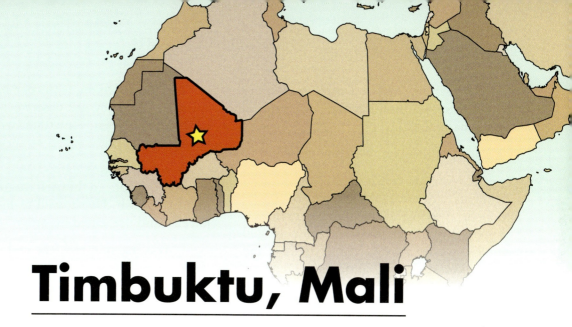

Timbuktu, Mali

The name Timbuktu has a mythical connotation. Many people are, in fact, unaware it's actually a real place. But it is. I've been there, and I found it utterly devoid of unicorns and rainbow bridges.

It's an outpost on the edge of the Sahara, linking it to the Niger River. It enabled trade between West Africa and the Berber and Arab populations to the north. It was also a center of Qur'anic thought, from which Islam was spread throughout the region.

Timbuktu served as something of a port town, the camel caravans passing in and out of the desert like ships at sea. But they were hardly as fast or efficient, and when Portuguese traders appeared on the coast in their capacious vessels, Timbuktu began its decline. Today, desertification has

finished the job, leaving Timbuktu a sweltering shantytown, half-devoured by sand and barely habitable.

None of this I knew before arriving.

Melissa and I visited some of the libraries—remnants of a once-fabled center of Qur'anic thought. We found one that let us inside. I suppose I was hoping to find walls of gilded scrolls—maybe a magic carpet or two and a dusty old lamp in need of rubbing. I didn't.

It was our good fortune, however, to arrive on a day when the Tuareg were in town for a festival.

Bona fide desert nomads, they live for months at a time amidst an endless expanse of sand. They preserve an ancient and unforgiving lifestyle, sharing little in common with the townies.

The most striking feature of many Tuareg is their eyes. They are desert eyes; shimmering blue and green, sometimes with a glint of yellow.

A young Tuareg named Muhammad graciously introduced himself to us, speaking perfect English. He showed us his handmade jewelry and presented his story.

"My camel has died," he said. "I must purchase a new one so that I can go to my sister's wedding in Zagora. It is fifty days by camel."

There were plenty of reasons to doubt his claim, but it wasn't worth making a fuss about and I was happy to learn what details

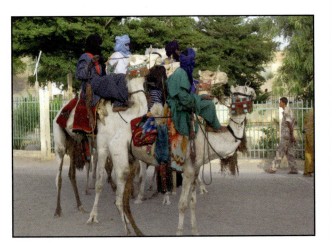

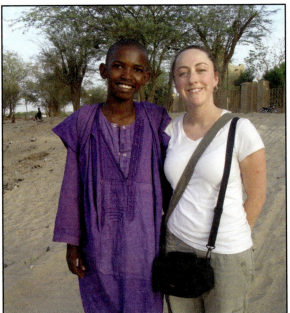

I could about his culture firsthand. Melissa bought a pipe and some necklaces while I kept him talking.

The Tuareg are tolerated by regional governments to the extent that they can cross borders at will without the need for passports. They are citizens of no country, bound only by the perimeter of the Sahara.

We wandered further and found some kids who were willing to dance with me.

The experience was fruitful, but it left a bad taste in Melissa's mouth, as it did a few days prior in Morocco. It still felt, to her, like we were taking something from the kids and not giving anything back.

We talked it over for a long time. I understood how she felt, but I believed strongly that what we were doing was ultimately a good thing. It was about more than just selling chewing gum, at least.

That's a dangerous attitude. Plenty of horrible deeds have been done for a perceived "ultimate good." My arguments were stifled by the nagging sense that she was right.

The difficulty, and the frustration, was that it was what we were there to do. We were making a video, and the premise was dancing with other people, regardless of social or geographical barriers. If the person holding the camera doesn't feel comfortable, however valid the concern, that put me in somewhat of a pickle.

But it was a pickle for another day.

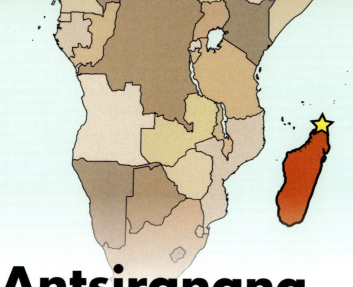

Antsiranana, Madagascar

I started making the 2008 video without really knowing what I was doing. Yes, there was all that stuff about dancing with other people, but for places like Madagascar, I figured I'd just keep looking for unique and interesting backdrops like I'd always done.

We hired a guide named Boris to take us to the Tsingy: a peculiar rock formation unique to Madagascar. On the way out to the rocks, we were crammed into the back of an old Renault taxicab.

We drove through a village in the early morning. All the kids had their backpacks on and were dutifully marching to school.

I yelled to Boris to stop the car.

"What's wrong?" Melissa asked.

I got out of the car. "Grab the camera and come with me."

We passed through the entrance to the school under close scrutiny from a hundred students. Their teacher came outside to see what was going on. I greeted him and found he spoke some English. I explained that I wanted to film the children dancing and offered a donation to the school. The teacher smiled and nodded; probably not what he'd expected that morning, but a welcome distraction.

We walked back to the car a few minutes later with a new understanding of what the project was about. I'd been making it much harder than it needed to be. I could keep hunting down strange and obscure wonders when I wanted to, but that wasn't at the center of what the video was becoming. And in donating to the school, I found a way to make it right. We could dance with kids and know we'd given them something meaningful in return.

Melissa was happy. I was happy. The kids were happy.

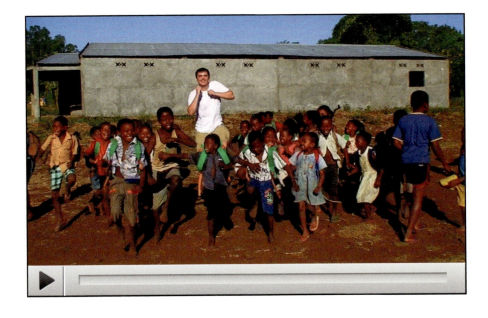

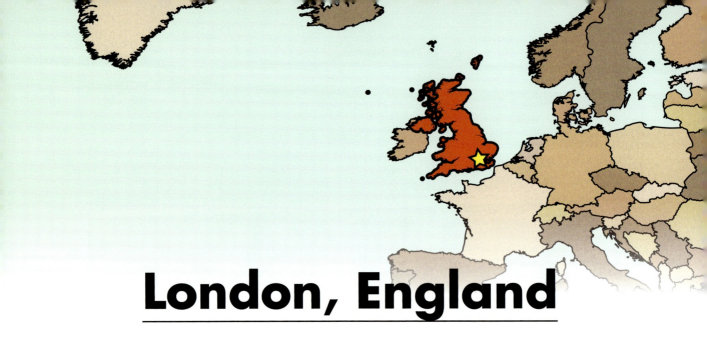

London, England

For years after the success of my first dancing video, I'd been taking the thousands of e-mails I get and filtering them based on geographic location. I had folders for virtually every country in the world, many of which were overflowing with requests to be included in the next video. As our plan came together, I realized I already had my global army of dancers ready and waiting.

Melissa and I looked at the numbers and picked the forty cities where we thought we could draw the biggest crowds to our organized group dancing events. I handed the lists for each city over to Melissa and she sifted through the e-mails to identify committees of five people in each location who seemed the most enthusiastic and committed to helping out. She worked with each committee to find unique and recognizable dancing spots where we could gather. This gave us vital local knowledge about places that we were, for the most part, totally unfamiliar with.

Melissa brought me reference photos for the two or three top location suggestions for each event, and together we'd narrow it down to the final choice. With the help of Google Maps and some rudimentary Photoshopping, I put together invitations that explained exactly where to be and when, then Melissa sent them out en masse. I encouraged people to pass the invites around to anyone who might want to come.

The system worked every single time, and it cost us exactly nothing.

The first time we tried it out was in London, where we did hit a small snag; we got booted from Trafalgar Square. Our numbers swelled past fifty as the designated dancing time approached. The security guards took notice and shut us down. There were lawyers in our ranks and they mounted an earnest protest, but there was no budging, so we walked a few meters over to the National Gallery entrance and danced in front of a stone wall.

One of the dancers asked if I'd mind him changing into black leather bondage gear: an outfit inspired by a Japanese TV personality named Hard Gay. I found myself unable to say no. After the first take, Melissa called me over and informed me that the bondage guy was thrusting his pelvis directly behind the head of a young boy in a red shirt. I'll give him the benefit of the doubt that he was unaware of his unfortunate trajectory.

I asked him to dial down the thrusting by 5 percent on account

of, "Ya know, there's kids that are gonna watch this." He obliged and switched to an innocuous round-the-world arm swing.

I regretted having to play the censor, but it'd have been a shame if I couldn't use the shot and everyone else had to lose out because of one guy's overzealous gyrations.

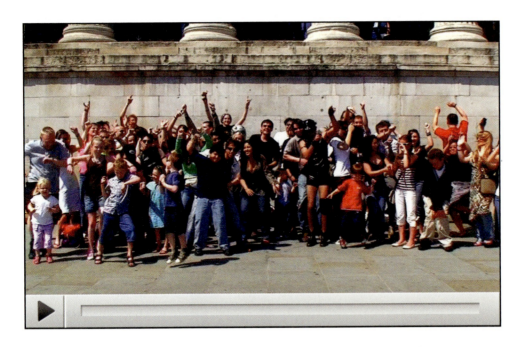

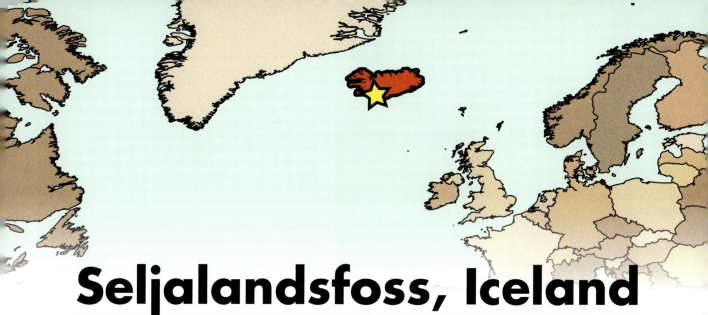

Seljalandsfoss, Iceland

In midsummer, the sun doesn't actually set in Iceland so much as dips across the horizon for a few hours in the middle of the night, then returns to active duty.

Combine that geographical novelty with a long layover and we were off and running with a thoroughly screwed-up sleep schedule.

After sleeping through our first day in Iceland, Melissa and I set off on a wee-hour wander through town—and town is about as far as you can go in describing Iceland's capital city. Reykjavik's population is under 200,000, which constitutes two thirds of Iceland's overall head count. The rest of the country is a smattering of farms and small communities.

In the summer of 2007, the Icelandic economy was still more than a year from imploding, so we had to deal with a wildly overinflated currency. To gauge costs, we had to start at the high end of reasonable and then double it. I paid twenty-seven dollars for a cheeseburger. The cumulative impact after a few days would have blown any sensible budget. We bought groceries and avoided taxis.

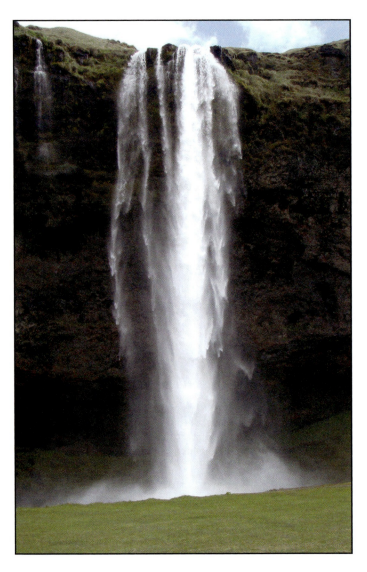

We did, however, splurge on a car rental so we could explore the countryside. The cost of the car itself wasn't too bad. Paying nine dollars for a gallon of gas was an adjustment, but it's to be expected and the island is mercifully small.

The Icelandscape is decidedly lunar. Volcanic residue, or "wasteland," accounts for over half the terrain. Another 10 percent is covered in glacier. There's only the occasional patch of green amidst the starkness.

We saw this waterfall from the road and had to pull over. It's called Seljalandsfoss—just rolls off the tongue, don't it?

We scramble up into the cave behind it and I danced in silhouette. By the time we got the shot, we were wet, freezing, and three full tour buses had just pulled up. It was clearly time to get going.

The next day, we shot a dancing clip in the center of town. I wasn't really against the idea; it just seemed like any dancing clip in Iceland should focus on the unique environment rather than the populace. Surprisingly, most of the populace felt the same way.

"Why are you dancing with us? Go find a waterfall."

On our last day, we stopped at Blue Lagoon on the way to the airport. This is sort of a mandatory excursion for all tourists. It's a big hot spring.

I don't quite get why people are so excited about hot springs. There's not much about a hot spring that I can't simulate in my bathtub. And in my bathtub, the only fat naked guy I have to look at is me.

We slathered on some pore-cleansing clay.

As we got seated on the plane, the flight attendant passed out copies of the national paper. There I was, dancing with the locals on the front page.

One might call that disconcerting.

Madrid, Spain

Something weird happened in Spain. We'd had a higher than usual response rate to our group e-mails, but we didn't quite understand why. We showed up in Plaza Mayor with an inkling that there'd be a good-sized crowd, and as more and more people kept appearing, we discovered there was some sort of plot underway. Word had got around on the blogs that we were coming, and the people of Spain decided they were going to generate the largest turnout of any country in the world.

They came from Pamplona in the north and Granada in the south. They came from Barcelona and Valencia—some even ferried over from the island of Palma in the Mediterranean. The mastermind behind the online effort was a guy named Remo, who turned out to be a wiz at real-world crowd management as well.

MADRID, SPAIN

With his help, we tried out an idea I'd experimented with in Ireland and Portugal earlier that week: the "run-in shot." Instead of just setting everyone up and dancing, I danced by myself with the crowd split to either side, and then after a countdown we had them all run in to join me.

It proved an effective way to loosen people up. When standing in one place, people tend to be stiff and territorial about their spot. When they run in, all of that is forgotten and the frame becomes filled with motion and energy.

Once we finished, everyone wanted a picture and a one-on-one dance recorded on their own camera. It took another hour, but they all left with whatever mementos they wanted.

Afterward, Remo and his friends took us out for tapas and beer. We quickly learned that accepting the hospitality of other dancers was the most enjoyable way to see each city in the short time we had.

It also gave me a chance to decompress. Having so much energy focused so completely in my direction for that length of time left me drained in a way I'd never experienced.

I'd put myself in a position that my wrinkly personality was ill suited for. I'd become a public figure of sorts. There were expectations to meet, but at the same time, there was the enormous satisfaction of making people happy just by, well, being there. I chose to adapt to my new circumstance and learned to portray, at least for periodic intervals, the person they wanted me to be.

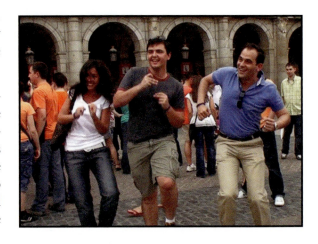

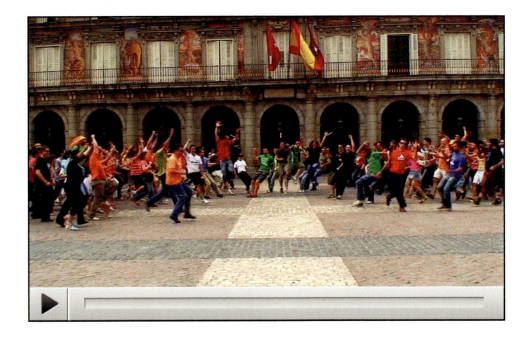

Israel and the West Bank

Whenever I'm asked about the message behind my videos, I do my best to play dumb and keep my mouth shut, 'cause I know that if I open it, I'm liable to sound even dumber. But there *are* ideas and motivations behind what I'm doing, and they're not too hard to figure out.

One of the things I wanted to demonstrate with the third video is the ability for simple human interactions to cross racial, political, and geographical boundaries. There are few places on earth where those boundaries are thicker than between Israel and the Palestinian territories.

Including Israel in the video was a foregone conclusion. I'd received hundreds of e-mails inviting me for a visit. When choosing where to dance, we were deliberate about picking a spot that was as religion-free as possible. That's a real trick in Israel, where the rock you're sitting on is probably where Abraham or David or Jesus once tied his shoe. We chose Dizengoff Fountain right in the middle of Tel Aviv.

The media got wind of the event somehow, and we wound up with almost as many news cameras as dancers. Melissa had to invoke her inner Israeli to shoo them out of the frame, which was fun to watch.

With that out of the way, we set our sights on the other side of the fence. Our hopes of getting into the West Bank city of Ramallah and visiting a school were dashed by flaring conflict. We tried every resource we could find, but the word was unanimous that "This is not a good time." So instead, we visited Jerusalem, figuring that was about as close as we'd get.

The Old City of Jerusalem feels a lot like Disneyland. It's broken up into four themed regions: Christian, Muslim, Jewish, and Frontierland. There are loads of souvenir shops and

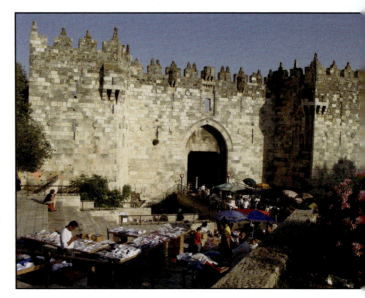

people running around in costumes. And the whole thing is based largely on make-believe.

In the Muslim quarter, we were surprised to find an open passage through the Damascus Gate, leading straight out into predominantly Palestinian East Jerusalem: a region with a disputed border that places it in both Israel and the West Bank, depending on who you ask.

There was a minor, relatively hassle-free checkpoint with no ID search or anything like that. Further down the road, a more severe checkpoint marked entrance into the West Bank proper, where we could not go without a well-documented reason.

We weighed the prudence of strolling through unaccompanied and totally oblivious to the circumstances and potential risks. Ultimately, we understood that there would be no other opportunity to represent this place, and we both felt it was important enough.

Like Rwanda, the West Bank is almost never seen outside a very specific, very negative context. These flashes of goofy joy, however trivial, work to counter the other images, and serve as a reminder of the underlying humanity amidst the awfulness.

I'm not sure either of us breathed for the first five minutes we spent wandering through East Jerusalem. The truth is, it really wasn't all that different on the other side—just a bunch of street merchants working, talking, eating, laughing. But our minds were playing through an imaginative list of horrific scenarios.

None of them happened.

What did happen is the same thing that happens everywhere: we ran into some kids playing in the street. We showed them the camera and Melissa filmed me dancing. The kids were puzzled at first, but there were some giggles. With their mothers' approval, they joined in.

I spoke to everyone I could find for guidance on how to handle the footage. One suggestion from a young Israeli stuck in my mind.

I told him I had a clip of Israelis dancing and a clip of Palestinians dancing. He cut me off. "Put them together," he said. "They must be side by side, one right after the other."

A year later, while assembling the final video, we struggled over how to designate our location in the clip. Melissa did research on where exactly we had been standing, and though I can easily show it to you on a map, I cannot conclusively tell you what the place is called. Like the larger conflict, it's a profoundly complex situation with two deeply entrenched points of view and endless, nuanced variations.

We resolved to put it in the "West Bank" instead of "Israel" or the blatantly incendiary "Palestinian Territory." I couldn't begin

to outline the history behind why that is or isn't accurate, but I'm content that there's at least some basis for placing us there.

I knew that no matter what we did, it was going to piss some folks off, and I did indeed get a handful of angry e-mails pointing out that all of Jerusalem lies within Israel and insisting that I correct the error. I wrote back to every person, sharing my point of view with varying degrees of success. But without exception, everyone acknowledged that the intent, however inaccurate, was a just one.

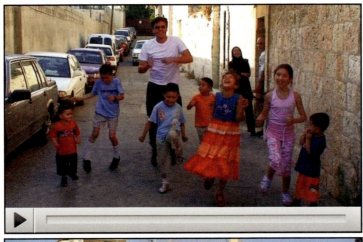

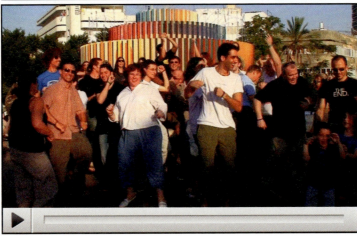

Vancouver, British Columbia

I didn't include Canada in my first video. This did not go unnoticed. I didn't include Canada in my second video either. Living in Seattle, the border is only a short drive away, so some speculated that I was trying to send a message.

I was asked on my site why I ignored Canada, and I explained that it was because I hate all Canadians. That answer did not go over well, and it served as an important lesson on the appropriate use of sarcasm in mass communication.

To me, the idea that I might harbor such hostility seemed ludicrous. I'd never heard of anyone hating Canadians. It would be like hating bread. But some took the comment at face value, so I kicked off the North America leg of my tour in Vancouver with an eye toward repairing the damage I'd caused.

Gathering at the Inukshuk sculpture on the waterfront, I was reminded that I'm way famouser than I used to be.

On my way to the hotel, I happened upon a group of people in creepy white costumes. They were staring at me.

A couple hours later, I got this e-mail:

Hey!

I think I saw you today. I was in Vancouver, B.C. . . . Was it you? I was an extra in a music video for a punk band. We were all dressed in white, and I saw a guy who looked like you walking by with a large backpack on his back and a small backpack on his front.

I feel like I just spotted Waldo.

Montreal, Quebec

About half an hour before the meeting time, rain started pissing down. I figured we'd be washed out, but tons of people showed up in Montreal, most with umbrellas, undeterred.

What is it about dancing in the rain?

With so many people joining me in this video, I needed all the participants to sign release forms that basically expressed their no-strings-attached consent to be shown in the video. This introduced a logistical hurdle to each event. During the obligatory release-form signing process, there were a handful of dissidents in the bunch. One challenged me to justify my outsized carbon footprint, which is pretty much indefensible at this point. Another read the terms of the release and walked off, unwilling to allow her image to be used in a project that is, ultimately, a commercial promotion. Fair enough, I suppose, but maybe slightly overprincipled.

I picked up a traveling companion in Toronto: a cameraman and documentarian from South Africa named Sean. He shot most of the clips in North America and many hours of background footage in between.

In the eighties, Sean was in the army. He fought in the South African Border War, which is something I'd never heard of. Its history is incredibly tangled and complex. After his patient explanation, I attempted to boil it down thusly:

"So, the United States was funding the South African military to fight Cuban soldiers in Angola who were, themselves, funded by the Soviet Union?"

"Yes. I'd say that's reasonably accurate."

Washington, D.C., United States of America

Filming permits were unnecessary for many of the places we danced in, but for the U.S. events, we wanted to make sure we were covered. We gave the folks at Stride gum a list of where we wanted to shoot, and they dealt with the paperwork.

This didn't pose much of an obstacle until we got to D.C. I wanted to shoot in front of the Jefferson Memorial as a nod to the guy who first suggested to the world that we were all pretty

much the same. The request was turned down because of protests against the war in Iraq scheduled for that day in front of the memorial. I tried pointing out the irony of being denied a peaceable assembly in front of a monument to the author of the First Amendment. The permit office of the National Park Service was unmoved.

We tried moving the date, but they told us the protest was going all weekend long. We tried moving to a different monument, but were told the protest would cover all monuments and memorials in the city.

So, to recap, we can't dance at any of the monuments in D.C. because there will be antiwar protests going on everywhere at all times?

I wondered if perhaps paranoia had taken hold, or maybe they just had an extremely broad definition of protest that included activities like talking and sitting.

I suggested just ending the war in Iraq so the protests could be called off. Again, the permit office of the National Park Service was not persuaded.

When you rule out monuments, the list of potential locations in D.C. gets a whole lot shorter. I suggested staging the dancing event in the permit office of the National Park Service. No one was enthusiastic about that either.

We had some hope of getting the entrance to Union Station, with its austere, triumphal

arches, but after leading us on for a few days, we were denied. This happened the day after we sent out all the invites.

Crap.

Changing venues once we'd sent out invites would cause chaos. Instead, we decided to meet at Union Station and just wing it.

Once we signed everyone up, I led the group down to a park near the Capitol Building.

There was a fountain. We danced. No one got handcuffed or tasered.

I continued our march down to the National Mall to dance in front of the Washington Monument. It struck me as sufficiently iconic, non-divisive, and visually interesting; but the light stunk for what we needed, so I used the first location.

My uncle, Rob, and his wife, Lucy, showed up. Rob and Lucy are both federal attorneys and former law professors at Yale.

There had been talk in my family about the nature of what it is that I do. I often declare myself, for the purposes of preemption, to be a "deadbeat." Talk to my aunt and uncle about their jobs and you'll feel like a deadbeat too.

I think the concern isn't so much about what I'm doing *now*, but more where it's leading. What am I going to be doing in five years?

I take a cosmic view on the subject—which is to say: I don't worry about it. Of course, this just makes everyone nervouser.

After attending the event, Rob declared that I was clearly making some kind of political statement in opposition to the capitalist work ethic, but he graciously spread the word that I'm something other than a deadbeat.

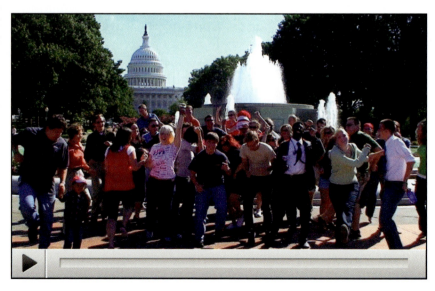

Los Angeles, California

Los Angeles is like the ex-wife I never had. We were terrible for each other. It just wasn't a good fit. But now that the wounds have healed and the paperwork has been filed, we get along okay. I've seen a lot of other cities. I've grown. Time to bury the hatchet.

I wanted to catch sunset on the beach. Of course, if I put the sun in the background, I'd have a bunch of dancing silhouettes, so I put everyone in front of the pier and pointed away from the sun. Timing the light was difficult, so I brought a huge supply of bubbles to pass around while we waited. Bubbles are a spectacularly cost efficient way to keep people entertained.

In the background, between the crowd and the pier, you can just barely see rows of white crosses buried in the sand. Those are symbolic gravestones for U.S. soldiers who died in Iraq—part of a protest that was going on that day, making this a profoundly incongruous image.

On the far right is Drew Shelley. Drew has muscular dystrophy and he gets around on an amazing off-road power chair. When I saw him approaching, I wanted to kick myself

LOS ANGELES, CALIFORNIA

for picking the beach, but it turned out to be the perfect venue for Drew to show off what his chair can do. You can see dancers watching stunned from the corners of their eyes as he kicks up sand and dashes into the surf.

Shortly after the clip was shot, Drew left on a solo backpacking trip to outback Australia and the jungles of Indonesia, so don't give me any excuses about why you can't travel.

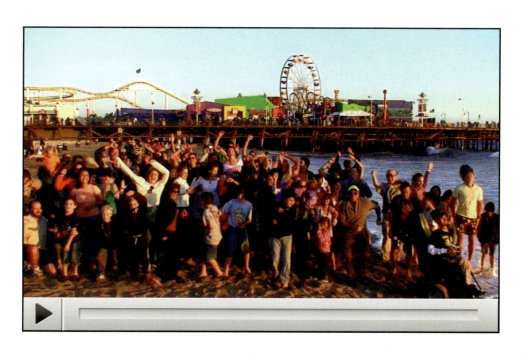

Tongatapu, Tonga

I had arrived on the island of Tongatapu, the capital of Tonga, with no arrangements for my final flight to the northern island of Vava'u. I sent a few e-mails to the dive operators I could find, but none were particularly interested in getting back to me. I'd explain my plans and itinerary and then get a reply along the lines of, "That's certainly possible."

I took the cue that Tonga runs at a characteristically Polynesian pace, and any attempts to prearrange anything would only make things more difficult.

I was abducted outside the terminal by a taxi driver named Teo. He took me to the "domestic terminal," which is a roof and some pylons with a separate airstrip a few minutes away. They sold me open tickets to and from Vava'u. I had about five hours to kill, so I let Teo take me around the island.

He showed me the fruit bats sleeping in the trees—thousands of them, with spiky blonde eighties hair that reminded me of *Lost Boys*.

We stopped by his house. I played with his puppies.

He took me to the blowholes: a spot on the island where waves shoot up to grand heights through narrow fissures in the volcanic rock that forms the coastline.

There were no other tourists around, no locals, no fences nor prohibitous signage to stop me from going out there. So, of course, I had work to do.

I've never used a tripod—which is, at times, abundantly obvious. But I had a feeling I'd be going to places on this leg of the trip where there'd be no one around to help me.

Affable as Teo was, I was glad to have three aluminum legs and a base to set up on the rocks.

It took me ten minutes to climb down and get in position. I quickly surmised the waves were much less scary than they looked. The rocks had already broken them into millions of tiny droplets, so the cumulative force of having it all crash down on me was much less than being hit by an actual wave of the same size. It knocked me over, but it wasn't enough to sweep me away.

I got one great shot and then decided not to push it. Volcanic rock is extremely sharp and painful even to touch. Losing my balance and getting dragged along it could have been a bloody mess.

So then I had to face the challenge of getting back up, which meant climbing about ten feet of said volcanic rock. Rock climbing is not something I'm very good at. Actually, I'm really, really bad at it.

Teo wandered along the coast looking for an easy enough place for me to ascend. We tried a couple black diamonds. I lost my nerve on a blue square. And finally we found a green circle that was sufficiently ladderlike.

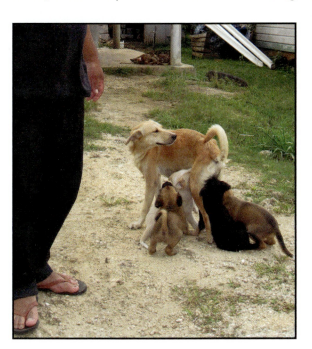

I discovered, upon returning to the car, that in the intensity of getting the shot, I failed to notice the waves knock my fancy prescription sunglasses off my head.

This is why I have a picture of my taxi driver wading around in his underpants.

I didn't ask him to go down there, but after watching me climb, I suppose he decided it would save us both a lot of suffering if he went down there himself.

The sunglasses remain lost to the sea, and I was left squinting through the South Pacific.

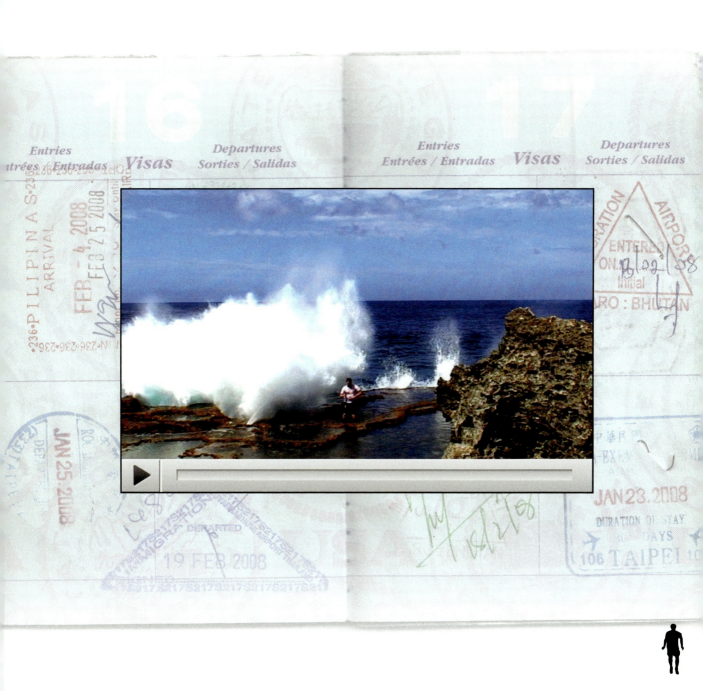

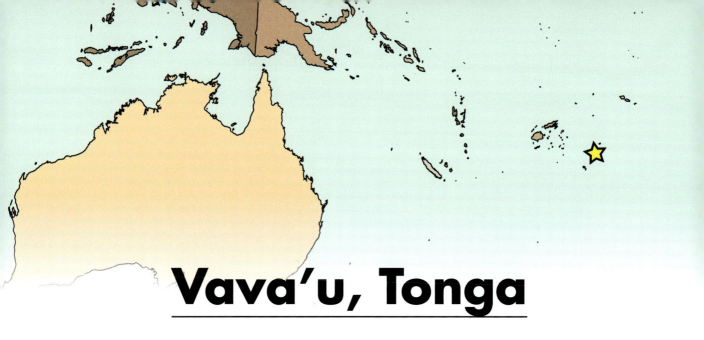

Vava'u, Tonga

Tonga is one of the only places in the world where you can jump in the water with a humpback. I was there at the end of whale season. Most had already left the warm, easy waters of the South Pacific and returned to Antarctica to feed. The seasons have been getting shorter each year, as the whales must work harder and harder to find enough krill to sustain them.

For a solid week, I tried every day to swim with a humpback. More than just another clip, it had been a fantasy of mine since childhood. At first, I went out with the big tour companies, but they took too many people and there was too much splashing. Each time we came close, the whales would swim off in disgust.

It wasn't whale watching. It was whale pestering.

I paid extra to charter a private boat, but bad weather kept us stuck on land. While I waited for the weather to clear, I shared a room with a Brit named Nick. He'd come to swim with a whale as well, and he was familiar with my videos, so I recruited him to be my cameraman. He was happy to help.

On day seven, Nick and I went out together with Honga, an accomplished local captain

and whale spotter. We tracked a mother and calf for several hours. They were skittish, but Honga was patient and considerate. He gradually got them comfortable with the boat and paid close attention to their behavior. When he gave us the sign, Nick and I slid into the water as gracefully as possible, hoping not to scare them away.

When I spotted the calf on the surface, I dove down and torpedoed in its direction.

I turned around to find Nick, but he was too far behind. I realized I was alone in the water with an unseen creature of enormous size.

Small, manageable panic attack. It passed.

And then I saw it—first the crisp white of its long pectoral fins, then, as it moved closer, the dark of its head and belly.

I forgot about Nick, forgot about the camera, forgot about the shot. I was overwhelmed by the sheer, magnificent presence of this leviathan.

As inconsequential as I felt at that moment, I was nevertheless in its way. It chose to dive down instead of swimming into me. I was about to lose my chance to get the shot, and there would not be another.

I turned back again to find Nick, and just as I did, he emerged from the blue with the camera already rolling.

I dove deep, positioned myself in front of the whale, and got four usable seconds of footage.

Wainivilase, Fiji

 I rented a car and drove along the Queen's road that encircles the southern half of Fiji's main island. About halfway between Nadi and Suva, I noticed a family playing in the ocean. I pulled off the road and sat for a long while, debating whether or not to go out and bother them. Wandering up to a bunch of strangers with a video camera can be obnoxious, not to mention creepy, but I knew I'd be kicking myself for days if I didn't at least try.

 I needn't have worried. As soon as the kids saw what I was holding, their heads exploded. This was one of the easiest and most enjoyable clips I ever shot. I still marvel at the acrobatic kid doing a flip into the surf behind me.

 I remembered to bring my notepad so I could write down where I was for the location text. The kids told me I was in a village called Wainivilase. I got them to spell it out for me so I was sure I had it right.

WAINIVILASE, FIJI

I have yet to find Wainivilase or any similar name on a map of Fiji. A search on Google turns up 142 references, all of which relate back to online discussion about the video.

I have no idea where I shot that clip.

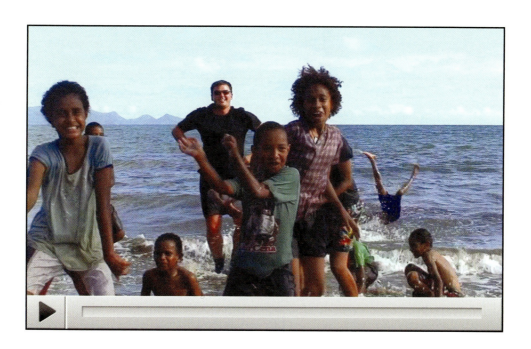

Auki, Solomon Islands

"Rorogwela" is the name of a traditional folk song from the Baegu tribe of the Solomon Islands. The song is about orphaned children, comforted that their parents are watching over them in the afterlife. "Rorogwela" was recorded in 1969 by a French ethnomusicologist named Hugo Zemp. The voice in that recording was from a girl named Afunakwa.

In 1992, "Rorogwela" was sampled by Deep Forest and used in a pop song called "Sweet Lullaby," which went on to become a huge international hit. More than a decade later, I "borrowed" the song as the soundtrack to my first dancing video.

I only discovered the song's origin after using the vocals again in my second video, having given no credit or compensation to Afunakwa or her family. I had a debt to pay.

That said, there didn't seem to be a great deal of *want* on the island of Malaita, home to the Baegu tribe. In my week there, I never heard a local say a word about what they didn't have. In material terms, they certainly didn't have much, but no one seemed to mind.

Everyone just kind of hung around. Without television or Game Boys to entertain the kids,

sports were a big deal. It was easy to find a game of soccer going on, or rugby, or volleyball. I even stumbled upon some improvised gladiatorial combat.

A *Little Rascals* vibe permeated the place.

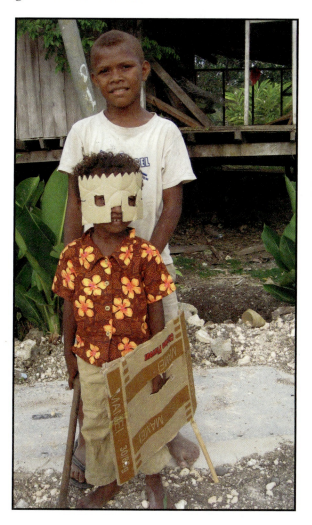

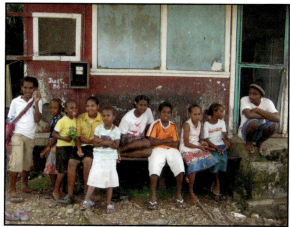

There was no shortage of smiles and greetings.

"Good evening," they would say.

"Good evening."

"Where do you go?"

"I'm just walking."

"Walking to where?"

"Nowhere, really."

"Oh. You go for a stroll?"

"Yes. A stroll."

"Okay. Nite nite!"

It took me a while to figure out that the word "stroll" explains everything. Once I caught on, the conversations went like this:

"Good evening."

"Good evening. I'm on a stroll."

"A stroll! Okay. Nite nite!"

I did a lot of strolling in the early evenings, after the midday heat and before dinner.

The rest of the time, I read old *Fantastic Four* comics and napped. Oh, how I napped.

When you think of housing in the Solomon Islands, think of a smallish, lumber-built room. The floor is wallpapered and the furniture has been placed to hold it down along its seams. There is a plastic chair in the corner that would collapse if you sat on it. There is a ceiling fan that provides comfort for as long as the electricity holds out. There is a thin bed in the corner. The pillow is stuffed with seeds. And you are lying on the bed, napping.

Catching the trail of Afunakwa was absurdly easy. I asked Collin, the manager of my hotel, and he brought me to Wilson, the local police chief. Wilson brought me to meet his "cousin-brother," David, who lives about fifty feet from the hotel.

I interviewed David at length and got him to translate the song for me. The next day, he brought me to his older cousin-brother, Patrick, who is Afunakwa's nephew.

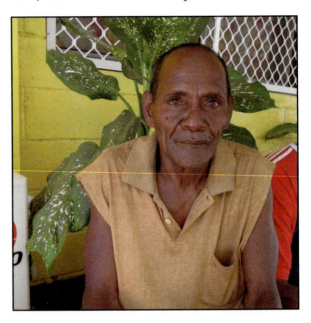

Patrick remembered the recording, which he accurately dated. He described the French man and his wife who made the recording, and the device they used, which he said was powered by a hand crank.

I made it clear that I wished to know as much as they could tell me about their music, and I'd be happy to give payment to him and to the family. I explained that I had used the recording in a project and done very well with it, and I wanted to give compensation.

AUKI, SOLOMON ISLANDS

Patrick confirmed that Afunakwa passed away in the nineties. He said her son, Jack, who was still alive, lived in the same Baegu village. We began discussing a trip to visit Jack, but it would have taken several days. I already had my ticket to leave, and missing the flight would have cost me a great deal of time and money.

We agreed that I would come back another time and arrange the visit in advance. No one is in much of a hurry on Malaita, so I decided it was okay to take my time. It's just some unfinished business.

With that out of the way, I worked up the nerve to intrude on morning assembly at the only school in the village. I spoke to the principal, explaining what I wanted to do, and offered a donation.

The kids were understandably mystified by the gigantic American who wanted to dance with them. They seemed amused, but absolutely no one wanted to be the first to join in. It is a bold thing, I soon recalled, to act the fool in front of your classmates.

I was flummoxed. This had not happened before. I found myself in a tremendously awkward situation with no backup plan, so I just kept on dancing until one brave soul decided to jump around with me. From there, it spread quickly and we soon achieved pandemonium.

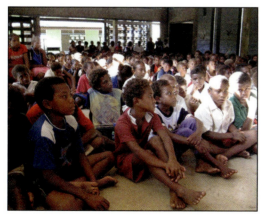
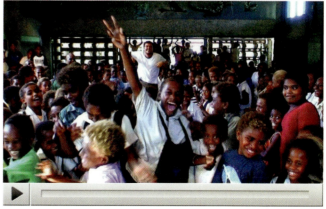

Poria,
Papua New Guinea

I saw a man standing alone on the runway as I got off the plane. The trickle of other tourists was packed away into a van and shipped off to some nearby jungle resort. The man seemed to be waiting politely for me to approach him, so I did.

"Hello. My name is Patrick. I'm a guide."

"I came here to find the Huli Wigmen."

"Sure. No problem."

"I'd like to dance with them if that's possible."

"Yeah, okay. No problem. Car is over here."

I was anticipating more of a challenge.

PORIA, PAPUA NEW GUINEA

Until fairly recently, the Central Highlands of Papua New Guinea remained one of the most remote human habitations on the planet. While the sweaty, mosquito-infested surrounding coast had been settled and partitioned out amongst European colonial empires for centuries, the cool, mild, mountainous inland region was deemed impenetrable and assumed to be sparsely inhabited—if at all. The advent of flight changed all that. In the 1930s, airborne explorers discovered a vast and prosperous network of agricultural societies living in isolation from the outside world.

The region has remained reasonably unmolested since its "discovery." Concessions have been made in clothing, language, and religion, but much of the tribal structure and attitudes remain intact.

The flight to Tari lands a couple times a week. When it does, the entire village stops what it's doing to watch. Here is the arrival terminal.

During the Second World War, tribespeople watched planes descend from the sky carrying vast resources for the war effort. Soldiers shared materials such as canned food, medicine, and weapons with the locals, who found them to be spectacularly useful.

Naturally, there was speculation about how the strange foreigners managed to summon these planes from the sky. When the war ended and the planes stopped coming, "cargo cults" emerged. They began imitating the rituals and practices they'd observed from the military in the hopes of producing the same results. Ad hoc runways were built, as were control towers, imitation radios, and communications headsets. Alas, no planes, no cargo.

Outside the airport, Patrick flagged down his friend, William, and convinced him to drive us around for the day.

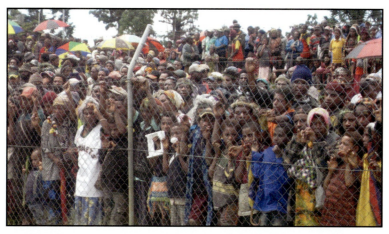

William had to stop and drop some of his kids off at his village. He invited me along for a visit. This entailed crossing a river on a bridge that appeared to be made out of branches and coat hangers.

Halfway across, I remembered I was carrying my laptop and all my camera equipment on my back. It also dawned on me that I'm at least fifty pounds heavier than everyone in the village. I made the mistake of looking down, then compounded my stupidity by trying to take a picture.

The villagers were amused by my presence. I pulled out my camera and tripod and invited them to dance with me. They thought that was pretty hilarious.

We continued on to the village of Poria, where Patrick knew a group of Wigmen who would put on their ceremonial garb for paying visitors. The process takes several hours, so we had to wait a while, but it was raining anyway. I sat under a thatched hut and read *Into the Wild*.

When the time came, I was led into a clearing where five Huli Wigmen were waiting for me.

The Wigmen play a spiritual role in the community. Only a select few Huli tribesmen are elevated to Wigman status. The wigs that give them their name are sculpted from their own hair and can take more than a decade to create.

I explained to Patrick what I wanted to do and he translated into Huli. Everyone seemed perfectly comfortable with the idea.

We tried things a number of different ways. To ease into it, I mimicked their dance as best I could, beating one of their drums and jumping alongside them. After doing that a couple times, I asked them to keep doing their thing while I transitioned into my regular dance. No one seemed offended in the slightest by my flailing. I showed them the playback and they soon got into it, debating which formation was best and choreographing their own variations.

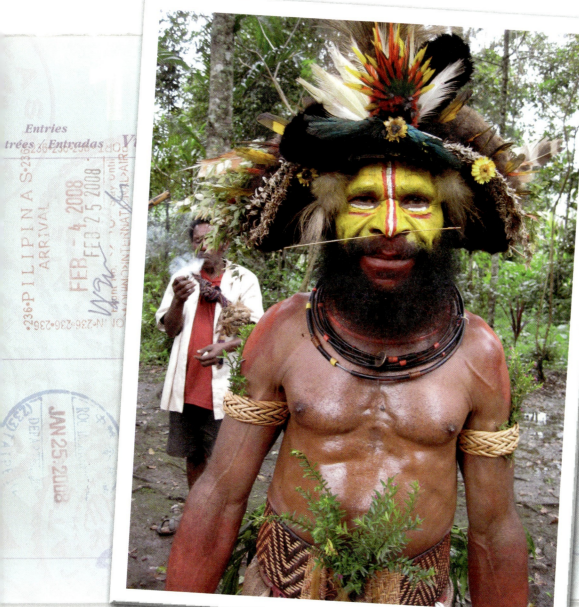

After a half dozen takes, I figured I had what I needed. Though everyone seemed happy to keep on going, I thanked each of the Wigmen and paid them for their time. I augmented their fee by picking up a couple of their incredibly awesome souvenir action figures.

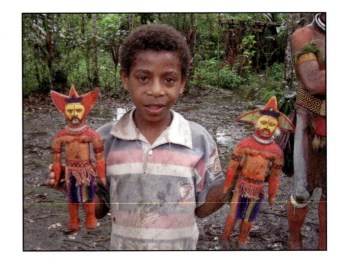

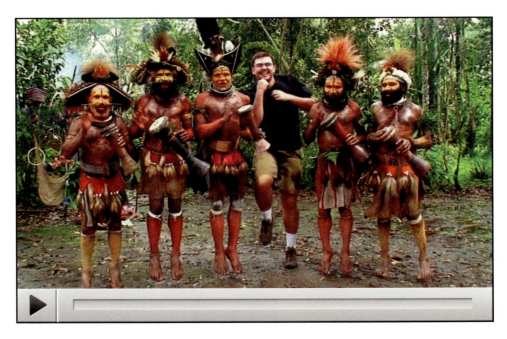

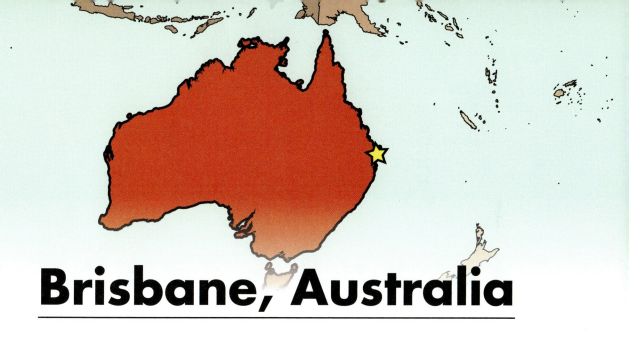

Brisbane, Australia

Back when I was designing games in Brisbane, the banyan tree in the city's botanic gardens was my favorite spot to visit. It's not much of a landmark, but I always found it fascinating.

"Banyan" is an Indian word meaning "merchant." The tree inherited its name from traders who would do business under the shade of its vast canopy. In fact, whole villages are said to have made their dwellings in the tangled network of aboveground roots extending from a single tree.

As I approached the site, I saw a kid sprinting back and forth along the pathways of the garden. By that point in the trip, I'd developed a sense for recognizing my dancing collaborators, and I was pretty sure he was looking for me, but I found him too entertaining to interrupt. Finally, he stopped and bent over, panting from exhaustion. He looked in all directions, then shouted, "Where the hell is Matt?!"

"I'm right here!" I said.

He turned to me, wide-eyed. "It worked!"

Lancelin, Australia

 In most of the places I visit, I have at least some vague idea of the shot I want to get. I'm simply moving too fast and covering too much ground to rely entirely on serendipity. But there are, from time to time, surprises that make it into the video.

 I flew into Perth late at night with the whole next day to kick around before my flight out to Christmas Island. The hotels were all packed, so I was forced to sleep in my rental car.

 At dawn, I drove north toward the Pinnacles Desert; an odd collection of natural rock formations that supposedly jut out of the ground like little stone soldiers.

 On my way there, I took a wrong turn in a town called Lancelin and found myself at the base of a sea of perfect white sand dunes. I left the car behind and marched in on foot.

 I set my camera up on the tripod, pressed play, and ran up along a ridge, doing my best to gauge framing and distance from in front of the camera.

LANCELIN, AUSTRALIA

As I danced, the powerful desert winds hammered against the tripod, and the fine grains of sand proved as abrasive to the camera as they were to my skin. This was something I hadn't anticipated.

I continued dancing myself into a coma as the tripod swayed increasingly back and forth with each gust of wind. I was at least fifty meters away, so there was nothing I could do but watch as the tripod finally keeled over and smashed into the ground.

The impact itself wasn't much of a problem, but in the minutes it took me to run back over, the sand particles crept deep into the mechanisms that make the camera function. By the time I got to it, the focus was jammed and it would no longer turn off on its own.

I was able to keep it going long enough to get a clip on Christmas Island a few days later, but the instant it hit the sand, its days were numbered. The desert killed my camera.

Christmas Island, Australia

Way, way out in the Indian Ocean, there's a tiny patch of land that is as strange and alien as any place I've been. What makes it remarkable, above all else, is its population of well over 100 million red crabs. To put that in perspective, the island's crab density is around five hundred times the human density of New York City.

The British discovered the island on the twenty-fifth of December. In keeping with the maddeningly irrelevant naming scheme that gave us Easter Island, they dubbed this place Christmas Island. I assume it went like this: "Wow, look at all those bright red crabs! This whole island is crawling with them. I've never seen anything like it. Anyway, Merry Christmas guys. Hey, let's call this place Christmas Island!"

CHRISTMAS ISLAND, AUSTRALIA

In November, the crabs migrate en masse from the inland jungles out into the sea to spawn. When the eggs hatch, the tide turns red with an impossible swarm of baby crabs coming to shore.

As I got off the plane, I texted Melissa about the sound of cracking crab shells when the wheels hit the runway. Unfortunately, my phone's predictive text garbled the message to say, "I think we ran over a bunch of *arabs* when we landed."

The one real settlement on Christmas Island is charmingly named Settlement. Settlement was originally built in the 1890s to aid in extracting the island's abundant supply of phosphorous. And by phosphorous I mean guano. And by guano I mean bat poop.

Today the island's population of 1,500 is an odd mixture of Chinese mine workers and Australian misanthropes. But I didn't come to dance with them. I came to dance with crabs.

The guy at the car rental place instructed me on the finer points of crab-dodging, of which there are few. It seems that crabs forgot to evolve a tire-evasion reflex, though I imagine it's developing fast, as the slower ones are being converted into curbside California rolls at an alarming rate.

Crabs use the roads a lot during migration, since roads generally provide a clear path to water. Crushing them used to be considered no big deal, but as ecological sensitivities have developed in recent years, folks have started to notice their declining num-

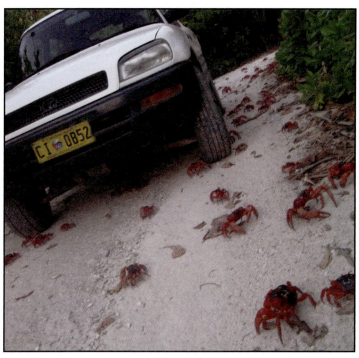

bers. Nowadays, roads are closed off when the crab flow is at its thickest, and slow, considerate driving is encouraged. Still, some casualties are unavoidable.

I had read about the red crabs and I was more or less prepared for them. I had no idea, however, about coconut crabs. I first discovered one while driving by myself through dense jungle on the far side of the island. The massive, arachnid-like creature emerged from the foliage and crawled right in front of my 4x4. I slammed on the brakes and got out to take a look. It had a leg-span of almost a meter as well as enormous, menacing pincers, and a face that resembled the alien from *Predator*.

Here it is preparing to devour my camera case.

As I've mentioned, I am terrified beyond reason of spiders and spiderlike things. Something about the leg movement triggers a primal fear and I go paralytic. The bigger the beast, the worse I freak out, until they get to around the size of a Volkswagen—and then it's just silly.

While not actually spiders at all, coconut crabs are at optimum scariness size, and my circumstance—alone in the jungle, mano-a-crabo—was a worst-case scenario.

I grabbed a stick and started shooing it off the road. The monster flared its pincers and, I swear, it hissed at me. It retreated toward the nearest cover, which turned out to be my car tire. I swatted at it some more until it finally left the vicinity, and then I got the hell back to Settlement and hid in my room for the rest of the day.

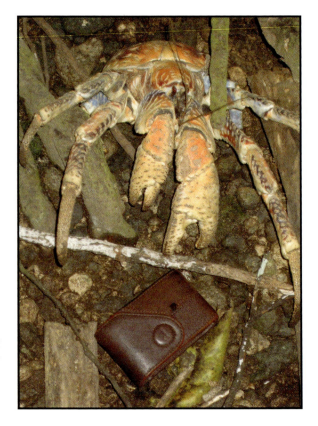

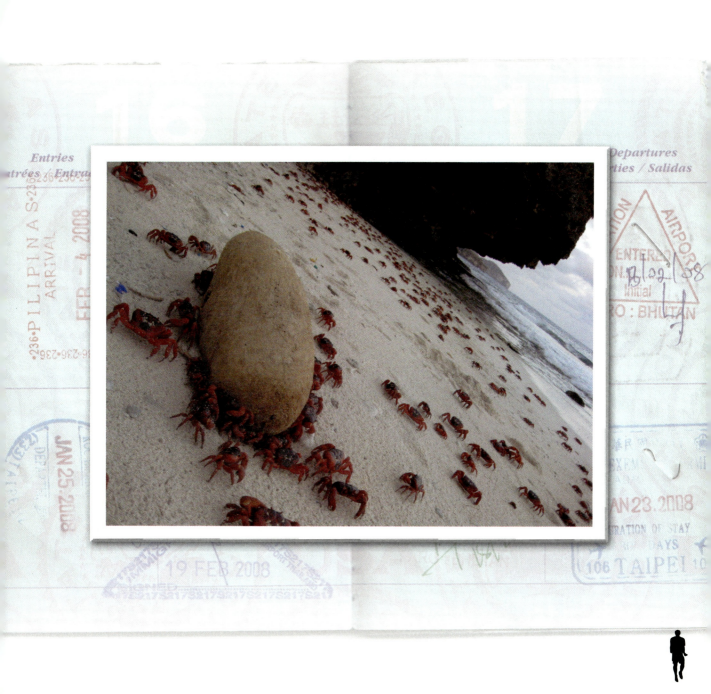

I ventured out again the following afternoon and found a beach where the red crabs were congregating. It appeared I'd found my dancing clip, until I got closer and realized the sand was absolutely covered in garbage. I met an Australian couple who were filling up rubbish bags.

They explained that the island's eastern facing coast was exposed to the Indonesian tidal current, and they were constantly bombarded with plastic refuse from coastal villages that throw their trash out to sea. Australian locals organize to clean up the shoreline from time to time, but it's a never-ending and utterly maddening task.

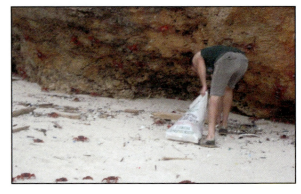

I grabbed a bag and chipped in, then placed my tripod down and got my shot before the sun went down.

The Australian couple stopped to look on, but said nothing about my odd behavior.

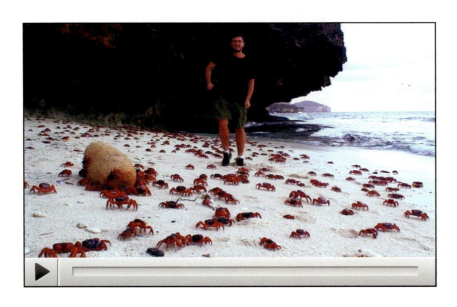

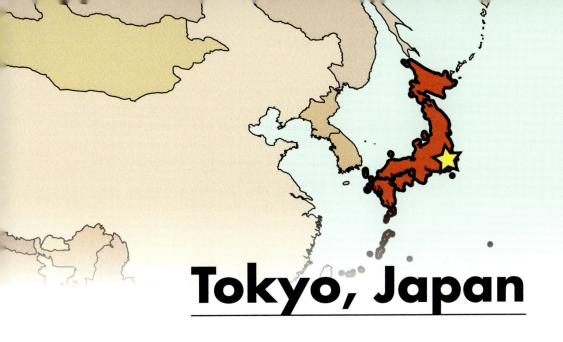

Tokyo, Japan

Checking into my capsule hotel involved an elaborate sequence of rituals, each of which I managed to botch terribly.

The shoes, I learned the hard way, come off immediately upon entering. You put them in an empty locker and remove the key, then go back to the desk and pay for the room. In return, they'll give you a manila envelope and a second key. The second key is attached to a rubber wristband. The shoe locker key, your passport, and any other valuables go in the envelope, which you hand in at the desk.

They rip off a claim tag so you can get it back. Hand them your luggage and they put it in the back room. They give you another claim tag for the luggage.

You go to a second, larger locker, take off all your clothes, put them inside, and remove the beige robes waiting for you at the bottom.

Once fleeced of all your belongings, wearing only a one-size-fits-most robe, you can make your way to your six foot by three foot, sound-proofed, capsule dwelling.

I loved my capsule, as I love any interior space that allows me to pretend I'm on a spaceship.

There are numerous communal facilities to enjoy. The men-only policy gives the hotel a vibe somewhere between gentlemen's club, military barracks, and ant colony. All the tables in the restaurant are one-seat, facing several giant televisions against the wall. If there were no women, all restaurants would be shaped this way. There's a vaguely non-chaste massage parlor filled with perky young women. The Internet lounge is free to guests, but you must, at all costs, avoid the urge . . .

. . . to smork.

I needed a shower badly, but I dared not engage in the Japanese equivalent: public baths. It was not modesty that gave me pause. It was the constant, looming fear of gross impropriety. I managed to infer that bathers are expected to wash themselves clean *before* entering the pool. This did not seem unreasonable; however, I had no idea how I was supposed to go about it.

Reading my guidebook's list of dos and don'ts filled me with dread. God forbid I should leave chopsticks standing upright in a rice bowl—a ritual offering to the dead. And what if spring allergies should force me to blow my nose in public? An unspeakable act, I'm told. I don't even want to speculate on what offenses I could issue by plunging my naked *gaijin* ass into a public pool.

TOKYO, JAPAN

I got invited on a Japanese talk show while I was in town. They decided to play a practical joke on me and cut the legs off all the chairs in my dressing room.

They hauled out prints of their favorite clips from the video to discuss. I spoke through a translator.

We danced.

After the taping, the producer of the segment, Daisuke, offered to serve as my guide for the remainder of my visit. I was thrilled. This is not something that would be likely to happen in, say, New York.

Daisuke lives way up north outside Tokyo. It takes him two hours to get to work every day—each way—but he prefers to live in the country so he can keep a vegetable garden and show his son what the color green looks like.

Daisuke took me out for a sushi dinner. I was given a big assortment of mysterious seafood items. I was brave and unsqueamish, despite my inclinations, and I finished everything. To cap it off, Daisuke ordered one last plate and insisted I try it, but he refused to tell me what it was. I protested, citing my pretty good track record up to that point. I told him I'd earned the right to know what I'd be putting in my mouth.

"It is," Daisuke relented, "the source of life for the man."

I get asked all the time what the strangest food I've ever eaten is. Before this trip, I never really had a good answer. So for the sake of a decent anecdote, I prepared myself emotionally and swallowed a bit of fish semen.

The next day, Daisuke was joined by Reijiro, another producer on the show. They

took me through Akihabara, Harajuku, and Yoyogi Park. We shot a dancing clip with about a hundred ecstatic participants in the freezing cold. To celebrate its completion, Daisuke asked if I wanted to go to something called Maidu coffee.

"What's that?"

"It is like a coffee shop, but the waitresses dress up as Maidu—similar to French maid."

I discerned from his expression that it was somehow illicit, but I couldn't quite tell *how*.

" . . . What else do they do?" I asked.

"They make conversation with customers and also play board games."

"What else?" I asked.

"That is it. Nothing more."

Maidu coffee was exactly as Daisuke described. A dozen or so older men skulked at the counter in the small café while the waitresses floated from customer to customer dressed in heightened interpretations of the French maid aesthetic.

Imagine a strip club, except instead of taking their clothes off, the girls giggle and play board games with you.

We were handed a *Pirates of the Caribbean*–themed game in which we each had to take turns sticking plastic swords into a plastic barrel. When Jack Sparrow popped his head out and yelled, that player was eliminated. Reijiro lost, so Daisuke and I got chocolate bars and he had to put on the kitty cat ears and meow for us.

I tried taking a picture of our waitress. She gave me a nervous but polite reprimand and directed me to a sign. Photography of the staff, it explained, is only permitted with payment of one thousand yen (ten dollars) per photo.

To help soften the blow, she spoke to me in English.

"Where do you come from?" she asked.

Before I could answer, Daisuke cut in. "He is famous American dancer."

The waitress went silent. She covered her mouth, then took a slow step back. For a moment, I thought I'd done something else terribly inappropriate, and then she shouted, "*You Tuuuube!*"

Everyone stopped what they were doing. The three other waitresses came over. They all had autograph books on them. Our waitress asked to take a picture with me. I pointed to the sign on the wall and told her it would cost "one thousand yen per photo."

I was kidding about that.

I asked if they wanted to dance with me for the next video. There was some deliberation with the management about whether they could be photographed with a non-paying customer. Daisuke followed the back-and-forth with great interest. When I asked for an update, he was bewildered. "This is very unusual situation."

Seoul, South Korea

Namdaemun is an ancient structure that once served as the southern gate for the walled city of Seoul. It's a symbol of national pride and identity for South Koreans, and it seemed a natural backdrop for the video. It's also well lit and I didn't have many night shots, so we decided to set the meeting time late in the evening and try to silhouette the dancers in front of it.

I got to the spot on time, for once. I was, in fact, the first person there, so I pulled out my book and tried to ignore the cold. 6 p.m., the designated dancing time, came and went. Still no people. 6:15, 6:30, I started feeling a little hurt.

Do South Koreans hate my guts? What'd I do?

Killing time, I stumbled upon a nearby plaque.

"Domdaemun (the East Gate) was built in the year . . . "

Hang on. Domdaemun. East Gate. East Gate? That doesn't sound right.

I pulled out my guidebook and found Domdaemun, the East Gate, on the eastern side of the city. Then I found Namdaemun, the Southern Gate, to the south.

I'd gone to the wrong gate.

In my defense, they look an awful lot alike. mean, it's a giant, ancient gate.

I mean, it's a giant, ancient gate. There aren't very many of them. You see one on the map and you go there. You're unlikely to be at the *wrong* ancient gate, right?

I was about to head back to the hotel in shame when it occurred to me that there might still be a few stragglers waiting at the *right* location. I hopped in a cab, raced over, and even though I was an hour late, there were still a good twenty people holding out hope.

They showed me a video taken minutes earlier of a much bigger crowd, now departed, dancing and shouting, "Where the hell is Matt?"

Like an arrow through my heart.

The bulk of the remaining group was an English class that had been corralled by their American teacher, Joshua. They invited me out to a Korean barbecue restaurant.

The evening was a great opportunity to interrogate a bunch of teenagers about their culture and their take on some of its finer points.

As a nerd, I'm familiar with South Korea's reputation as home to the most fanatical gamers in the world. There are stories of

kids spending weeks in front of their computers, dropping dead on their keyboards from malnutrition, tales of violent real-world retribution for slights committed between rival online gangs, special police task forces assigned to deal with it all. Weird stuff, and apparently not far from the truth. One of the dancers confessed he almost didn't come out that night because he was playing *StarCraft*. It took the persistence of his entire class, texting him repeatedly, to get him off his ass to join in.

Back at the hotel, I sent out an apology e-mail with accompanying photo.

I invited everyone back in two days to try again, and when the time came, I found an even bigger crowd waiting for me, filled with forgiveness and understanding. We danced.

And then, twelve days later, the six-hundred-year-old structure of Namdaemun was burned down by a crazed arsonist.

The video came out five months after its destruction, and served as a bittersweet reminder for many Koreans. I received emotional messages of gratitude for commemorating the structure as it once was.

And it's not just structures that have passed away. Over two thousand people danced in the third video, and in the short time since it was recorded, I've been informed that several are no longer with us. And it goes without saying: that number will steadily approach zero.

It sounds strange to suggest, but I think a lot of us are at our best in those moments when we're willfully, unselfconsciously ridiculous. And for me at least, I think it's a pretty great way to be remembered.

Demilitarized Zone, North Korea

The Demilitarized Zone is a band of terrain 4 kilometers wide and 250 kilometers long, running roughly east to west between the two Koreas at thirty-eight degrees north latitude. It is the most heavily guarded border in the world—a fault line dividing two radically opposed social philosophies.

The fault line metaphor was extended to the point of absurdity by a South Korean educational video they showed my tour group upon entering. The video started with a little girl wandering through the forest. Suddenly, the screen turned red and sirens blared in the distance. She became frightened and dropped to the ground for cover, but then the ground split open and swallowed her into a massive fissure. Another victim of the Demilitarized Zone.

Holy crap!

Pictured below is the tallest flagpole in the world. Mounted atop it is the largest flag in the world. It stands in the center of Kjong-dong, border city on the North Korean side.

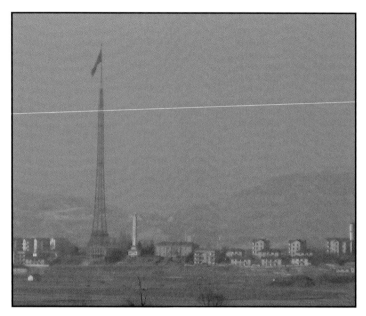

Here's what's amazing about Kijong-dong: it's empty. No one lives there. It's a fake propaganda city that was built as a rebuttal to a farming village on the South Korean side. South Korea had a village, so North Korea had to have a city. South Korea put a really big flag in their village, so North Korea built an even bigger one.

The tour took us into one of the North Korean invasion tunnels. Throughout the 1970s, South Korea kept finding underground tunnels built under their feet by North Korea in an effort to mount a surprise invasion. The plan was to get one of these tunnels far enough across the border that they could emerge in an unwatched patch of forest and pour through hundreds of thousands of infantry before anyone noticed. Ignoring the glaring impracticalities of trying to invade a country on foot, it still scared the bejesus out of South Korea, which is fair enough.

This is the main building on the North Korean side of the DMZ. There is a teeny tiny man at the top of the steps. When our tour group stepped out of the building on the South Korean side, it was his job to take photos and stare at us through binoculars. Visitors were instructed not to make eye contact with the North Korean guards or gesture to them in any way.

This scenario begs the question: What would happen if you just ran for it?

Good question.

If you're on the South Korean side and you head north, the South Korean guards would do everything they could to stop you. If you made it across, there'd be nothing more they could do. The North Koreans would (probably) not shoot at you. They would welcome you into their country, take you in for questioning, and try to figure out some use for you.

Apparently, there's a German guy who believes he's destined to save the North Korean people, and every year or so he shows up on the tour and tries to get across. He has yet to succeed.

Now if you're coming from North Korea and you want to head south, the situation is very different. In 1984, a Soviet tour guide named Vasily Matauzik made a run for the border. Several North Korean guards followed him across, guns blazing. South Korean guards fired back. Three North Koreans and one South Korean were killed.

Vasily lived.

This photo was taken inside the meeting room that straddles the border between North Korea and South Korea. The border runs through the middle of the conference table. It is permissible to walk past the table and stand in the forty square meters of the room that is, technically, North Korea. While we were there, a South Korean guard was posted in front of the door that led out the far end of the room and into North Korea proper. He stood in a modified tae kwon do stance designed to render him an unmovable obstacle. We were instructed not to touch him.

I asked the USO tour guide for permission to film myself dancing in front of the door. God bless him, he couldn't see a reason why not.

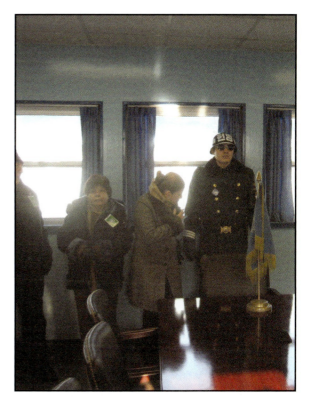

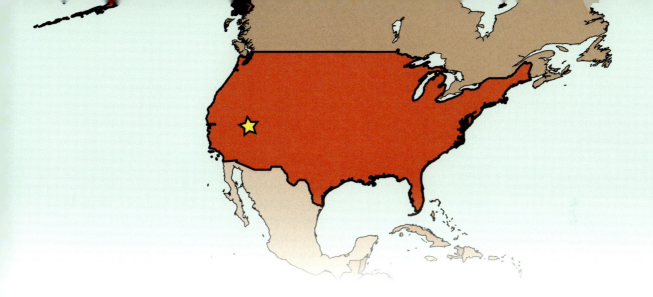

Nellis Air Force Base, Nevada

I arrived in Vegas and had dinner at the Hooters casino. My waiter was named Tom.

Tom, you don't have hooters. Where are your hooters, Tom?

I felt kinda ripped off until I realized I was in the Dan Marino steakhouse *within* the Hooters casino—which apparently supersedes the established Hooters precepts. You might encounter hooters. You might not. Anything goes.

Fortunately, my reason for being in Las Vegas had nothing to do with Las Vegas. I was there to dance in a weightless environment.

I showed up at an office park address just off the Strip a little after 8 a.m. The sign out front said ZERO G: a whimsical operation founded by Peter Diamandis to bring parabolic flight to the masses—or, at least, the masses who can afford a ticket.

Parabolic flight is a way of simulating weightlessness. The plane performs a series of fifteen ascents and dives; they call them parabolas. In the ascent portion of each parabola, passengers are pulling two g's. A g is a unit for measuring the force of gravity. One g is equivalent to earth's gravity, so pulling two g's means you weigh twice as much as normal. During the descent portion, you are brought down to zero g's, which is effectively weightlessness. Each cycle of the parabola lasts under a minute, so you get about half that time to fly around the cabin before getting pinned back to the ground.

I suited up and watched the training video, then loaded onto a bus for the ride to the airport.

The plane was a hollowed-out 727. Pretty small as commercial jets go, but with the overhead compartments removed, I could only just touch the ceiling. They'd left enough seats in the back of the plane for everyone to buckle in during take-off and landing. Once the plane reached cruising altitude, we were free to move about the cabin.

I was placed up front against the bulkhead. This was one of the requests Zero G granted to me. The other was pairing me up with Todd, a crewmember who volunteered to hold the camera. The folks at Zero G were familiar with my video and eager to help out.

The crew had everyone lie down during ascents. This keeps the blood evenly dispersed in your body and minimizes the likelihood of passing out.

As the plane reached the summit of the first parabola, the 2 g's shifted to about 0.4 g's in the span of a few seconds. This approximates Martian gravity. They had us all do push-ups, and then attempt one-handed push-ups.

The second and third parabolas brought us to about 0.2 g's, which is lunar gravity. At that point, one-fingered push-ups weren't much of a challenge. A vigorous push and I would've smacked into the ceiling.

From there on out, it was 0 g's as we plummeted from 32,000 to 24,000 feet, then climbed back up to do it again.

Before going up, I imagined weightlessness would be a relaxing, Zen-like experience. I had visions of Kubrickian solemnity, silent except for, perhaps, some Strauss or Beethoven playing in the background.

Not at all accurate.

As it turns out, when you put forty people in a hollowed-out tube and give them twenty-five-second intervals in which to fulfill their childhood dreams, what you get is basically a three-dimensional mosh pit. Any attempts at transcendent bliss are interrupted by grown men doing cannonballs into your face. So you pretty much have to give up on an internal experience and just go with it.

For budgetary reasons, I went by myself. I didn't know anyone else on the plane, so there was no one to bounce back my unbridled joy. When your ass suddenly flips over your head, and up is no longer up and down is no longer down—I don't care who you are—you

turn eight years old. It's the sort of thing you want to share, which made me reflect on Alan Shepard and John Glenn and those other first few guys—the absolute solitude they must have felt up there, envied by all but frustrated by their inability to transmit the experience.

For the last five parabolas, I brought out my camera and moved up against the bulkhead, where my designated cameraman and I got ready. I was shooting with a brand-new Sony high-definition camera that recorded its footage onto an internal thirty-gigabyte hard disk drive.

Here's where I learned something important: All hard disk drives, as it turns out, contain a failsafe mechanism that disables their ability to record when they're falling. The needle moves off the platter to prevent any damage to the existing data. As far as the hard disk drive is concerned, there's no real distinction between falling and simulated weightlessness. That meant that every time we started recording, the camera would immediately shut down to prevent itself from getting damaged. After all the money and time I put into the clip, I was unable to shoot anything I could use.

I went home devastated by the experience, but disinclined to give up on it.

The Zero G folks were nice enough to sell me a second ticket at cost. Six months later, I bought a new camera that recorded onto solid state memory sticks, so there were no moving parts to get disrupted.

On the very last parabola, everything came together perfectly and I got the shot that's in the video.

This clip goes down as by far the most expensive one in any of my videos, but it was, of course, worth every penny.

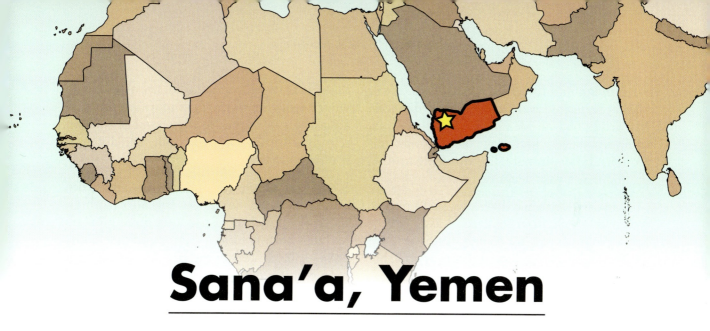

Sana'a, Yemen

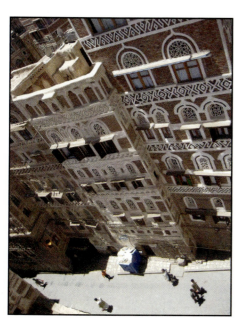

I got into Yemen at 3 a.m. The moment we were released into passport control, the passengers charged the counter like it was a wedding dress sale at Filene's Basement Warehouse. I threw a few elbows to keep my place in line and made it out with minor bruising.

The city of Old Sana'a is thousands of years old. Its buildings would be considered modest skyscrapers if they were built out of concrete and steel. As it happens, they are built out of mud, which makes them tremendously immodest. They're crammed tightly to maximize shade in the winding alleys. Few cars dare to risk scraping through the place, so the sounds that *can* be heard bounce great distances to a haunting effect.

Driving into the city, hours before dawn, all that registered were a few scattered voices. My driver had no idea where the hotel was, so he woke every urchin we passed to ask directions. It felt intimate, like tiptoeing toward the toilet at a vast sleepover party.

Sana'a is extremely high up: 2.200 meters, well over a mile from sea level. I assumed the Saudi peninsula was just endless, flat desert. Not so. The altitude keeps Sana'a relatively cool, but I lost my breath on the stairs up to my room.

Any traveler familiar with the area knows what I woke up to the next morning. At 4:30 a.m., the city shakes to the sound of the call to prayer—broadcast from old, scratchy bullhorns atop minarets.

A few minutes later, Melissa called from Seattle to make sure I was still alive with all my parts attached. Turns out three mortars had just been fired at a compound that houses U.S. oil workers in the city. The group that took credit linked themselves with the mysterious bogeymen we call al-Qaeda.

No one was hurt.

I'd planned to hire a driver and visit some nearby villages, but that plan seemed ambitious given the circumstances. I spoke to Abdul, the hotel manager who'd arranged things for me, anticipating that he would dismiss my concerns.

"It is not for you that they are angry, Mr. Matt. You must not be afraid. These men, they are not from Yemen. They come from Egypt and other places and they make trouble, but Yemeni people will not harm you."

I stewed for a bit. I agreed with his point about not being afraid. You know, "the terrorists win" and all that. Also, what had really changed? I already knew those guys were lurking. Like most humans, my caveman brain responds enthusiastically to sudden,

visceral events like explosions and is largely indifferent toward gradual catastrophes like climate change and economic collapse. I tried to put the risks in perspective.

With no one around to discourage me, I went ahead with the plan. I met my driver, Mujahid, which is an Arabic name that means "one who struggles," not to be confused with its plural form, "Mujahideen."

Deep breath. Shake hands. Keep smiling.

Like most Yemeni men, Mujahid wore an ornate, jeweled dagger in his belt, called a *jambiya*. They're part of the formal dress—similar to neckties, except easier to kill people with. They're passed down through generations and are often quite valuable.

Mujahid had been driving tourists around Yemen for twenty years. Mostly Europeans, he said. But, of course, "Americans are the best!"

He was curious about prices in America. He wanted a sense of the relative cost of goods, so he chose the most universal of purchases.

"How much for a chicken?"

" . . . Uh, cooked?"

"Yes."

"I don't know. Maybe twenty dollars?"

"Twenty dollars! Amazing. And how much without cook?"

"Sorry?"

"How much for the whole chicken. Still alive."

I couldn't think of ever having seen a live chicken for sale in my country. Mujahid found this puzzling.

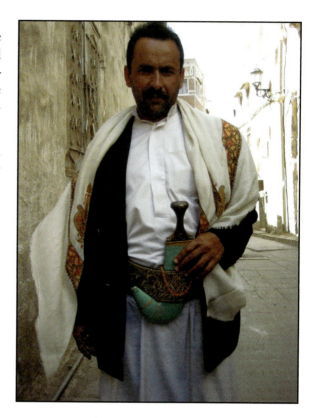

We continued on, visiting Thille, Kawkaban, and the palindromic village of Habebah.

The next morning, I spent an hour exploring Sana'a, and four hours trying to find my way back. No street goes in the same direction for more than a few meters, so navigating was hopeless, even with a map.

A good portion of the folks I passed greeted me warmly. Lots of smiles. They'd ask me where I was from. Big thumbs up. "America! Very good!"

Pictures of Saddam Hussein aren't at all unusual in Yemen. Lots of shops have them. I imagine his image means something very different to Yemenis than it does to me. I suppose he could be a sort of Teddy Roosevelt figure: strong, willful, defiant. From a certain point of view, Saddam was a real can-do guy.

I passed a little girl. When she saw me coming, she lit up and said, "*Sura!*" I assumed that meant she wanted money, so I smiled and kept walking.

"*Sura! Sura!*"

She stood, somber and alone in the alley as I walked away.

"*Sura . . . ?*"

I waved goodbye and turned the corner.

"*. . . Sura.*"

Sura means picture. She just wanted a picture.

Digital cameras have profoundly changed and enhanced international travel. Suddenly, I have an infinite supply of something that's easy to give and as fun for me as it is for those who request it. Today, an image is treated like a disposable thing, but good ones are still very powerful.

Anyway, once I found out what it meant, I never missed another *sura*.

My *sura*-taking attracted attention, and soon I had a small crowd.

I pulled out the video camera and started shooting. The kids were hamming it up, and it was a smooth transition into positioning the tripod and getting them to dance with me.

I showed them the first take and they sort of got what I was doing. We moved back in position to shoot it again. This time, just as I started dancing, they all pulled out their *jambiya* and waved them in my face.

Everyone was still smiling and laughing, so I figured I wasn't about to get stabbed. I eventually cottoned on that dagger-wielding is part of their traditional dance.

Okay, then.

They circled around me, thrusting and

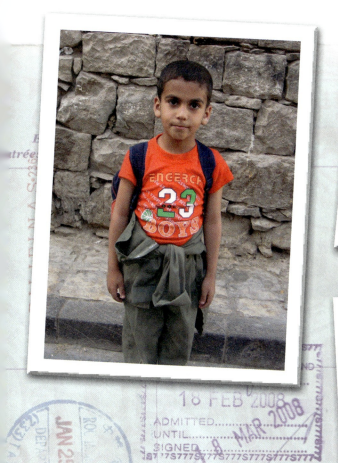
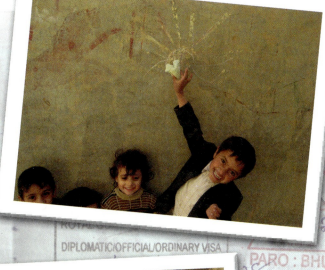
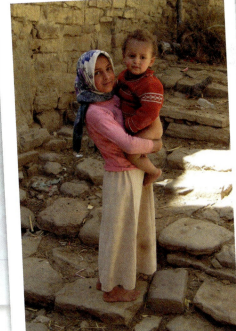

twirling their not-at-all-unsharp blades. One dagger slipped out of a kid's hand and landed at my feet. I pretended not to be terrified and kept on dancing.

This batch of kids really wanted me to eat their cookies. I politely declined. That was deemed unacceptable.

I ate a cookie. It was fine. They immediately produced another one. Okay. I ate that too.

Out came a third cookie. *What the hell kind of game is this?* I let them know I was done eating cookies. So they took my backpack, opened the main pouch, and stuffed the entire bag of cookies inside. I guess they just really wanted to get rid of those cookies.

I pulled the camera out. They swooned with excitement. We danced.

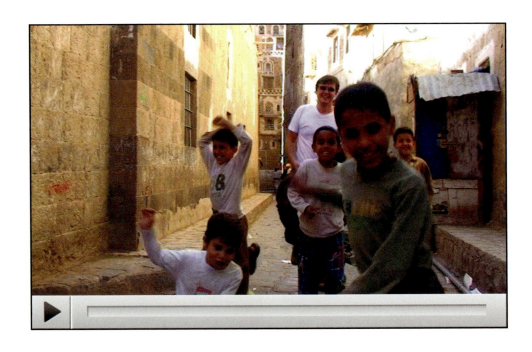

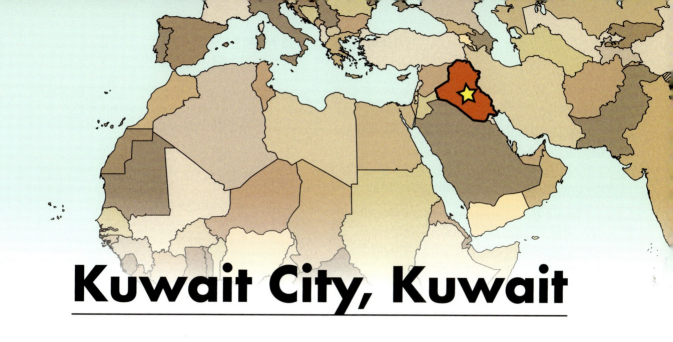

Kuwait City, Kuwait

I pulled my laptop out on the flight to Kuwait. The act jolted the Sri Lankan man next to me from his slumber. He launched into a rant about computers and their destructive effect on modern life. He instructed me that I would be much better off getting rid of the thing.

"When I am at work, I work. When I am at home, I am home. That is how it should be."

"It's difficult to draw the line these days, isn't it?"

"Very much."

Vidula was an engineer living in Bahrain. He went around the region helping commercial airlines maintain their engines. I opened up my flight simulator program and put us on the runway at Kuwait International in a 737. He looked over the cockpit controls, tweaked dials here and there, and adjusted the fuel mixture and whatnot. He pushed the throttles forward, took off, and piloted a thrilling thirty-second flight before flipping the plane and crashing into a sand dune.

To be fair, it's not easy piloting a commercial jet with arrow keys.

Somehow this led to Vidula sharing his thoughts on colonialism. He felt that Sri Lanka got what it deserved when it was absorbed into the British money-making machine.

"If you leave the front door of your house open and someone comes in and steals all your things, how can you blame them?"

"Uh . . . because it's wrong?"

"We left our front door wide open. It was foolish."

And, inevitably, he whispered his thoughts on Iraq into my ear.

"I think what George Bush did was the right thing. These people, they have become too big for their britches. They needed to be taken down. It was the right thing to do. However, the way in which it was done was a big mistake."

"Well, at least that last part is something we can all agree on."

I saw the wineglass-shaped, blue-and-white-striped water towers on my way in from the airport. Water is a precious resource in the small desert nation of Kuwait. The structures are dotted all over the city, but they're not easy to get to without a car. By the way, *nothing* in Kuwait is easy to get to without a car.

I called a few rental places. The best deal I could find without notice was a BMW 530 for three hundred dollars a day. Not going to happen.

Instead, I got in a cab with an Indian driver named Nissar. I asked him to take me to the blue and white water towers. After great deliberation, he figured out what I was looking for and took me to a construction site on the outskirts of the city.

As it turns out, the two larger spheres of the Swedish-designed Kuwait Towers are indeed filled with water. It's certainly a unique structure, but it's also 185 meters tall. Stuff that tall doesn't really work well for what I'm doing.

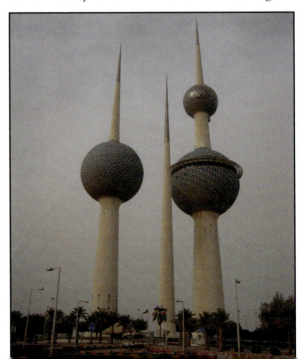

After great deliberation, Nissar figured out what I was looking for and took me to a construction site on the outskirts of the city. He stood next to me while I set up the shot and tried to figure out what the hell I was doing.

All of a sudden, Nissar shrieked and leapt in the air. He grabbed a clump of sand and threw it in the face of a stray dog that had crept up behind him. From his reaction, you would have thought it was a grizzly bear.

"Are you not afraid?" he asked.

"Afraid of what?"

"This dog!"

I let the dog smell my hand, then scratched him behind the ears and we were friends for life.

I continued with my business while Nissar stood at a safe distance, a fresh clump of sand in his hand.

The dog followed me over to the towers. When I started dancing, he did too.

As I walked back, Nissar fled to the safety of his taxi. The dog turned to me and asked, "What the hell is this guy's deal?"

Back on the highway, I told Nissar I had the rest of the day to see Kuwait and asked where I should go. He laughed.

"There is nothing in Kuwait," he said. "Only money."

Ala Archa Gorge, Kyrgyzstan

 I arrived in Kyrgyzstan to an unfortunate set of circumstances. It was 2 a.m. and I was alone in an unfamiliar country with an unfamiliar language and an unfamiliar currency, facing a cluster of unlicensed cab drivers, all jockeying to take me into town.

 A traveler is generally most vulnerable in the minutes immediately following arrival. Multiply all risk factors by five when you're in a country that ends in the letters *s-t-a-n*.

 I chose the least pushy driver I could find and watched him physically block his competitors from climbing into the back seat with me.

 I soon found myself on a desolate stretch of road heading toward the capital city of Bishkek with my driver, Eric, who spoke a bit of English and his sidekick, Boris. That was my biggest and least forgivable error: never get in a cab when the driver has backup. At the time, I was thrilled

to escape the airport parking lot in one piece, but I should have been more alert and blown the whistle before it was too late.

Eric pulled off the road into an unlit service station. He said he needed to buy gas and asked for full payment up front. It's annoying, but not uncommon in much of the world for drivers to pick up fares with an empty tank.

"How much was that? Twenty-five?"

"No. Not twenty-five. Price is one hundred twenty-five."

"Excuse me? A hundred and twenty-five som? We agreed on twenty-five."

"No. Not som. Euros."

I'm going to skip over a lot of math here and explain that Eric had swapped out not only the price, but also the currency. In doing so, he had jacked up the cab fare from about one dollar to two hundred dollars.

In hindsight, the initial figure was surprisingly low. In my sleep-deprived state back at the terminal, I forgot to carry a zero and thought he was asking for a fairly reasonable ten dollars. Now here I was being held up for an entirely different figure, and I was no longer holding any cards.

I faked a look of fearless indignation, and said, "Please, Eric. Don't do this."

Eric quickly became angry, and I could see things were about to deteriorate quickly. I grabbed my backpack and got the hell out of the car. Unfortunately, my luggage was still in the trunk.

Another taxi from the airport was also just pulling in. I flagged it down. The driver spoke no English and neither did his passengers, but my situation was pretty obvious.

I pulled out some cash from my wallet and asked the passengers through gesture what the fair price into town was. They showed me that it was four hundred som, which is eleven dollars.

I turned to Eric and told him I'd pay four hundred som and that was it. He countered, not surprisingly, with one hundred twenty-five euros.

I thought about imposing on the passengers to let me in the cab with them, but even in my dire situation it seemed awfully rude. And more importantly, they had my luggage.

I made for the trunk as fast as I could, but they blocked it. The other taxi drove off.

I started bartering in earnest, and we finally settled on one thousand som, or about twenty-eight dollars. I stood about five meters away from them and took the cash out of my wallet.

"Take the bag out of the trunk."

They opened the trunk and pulled the bag out.

"Put it on the ground."

They put it on the ground.

"Step back."

They stepped back.

I moved toward the bag and reached out with the one thousand som. They took the money. I grabbed my bag.

"Now leave!"

They left.

I've gotta admit, the bag exchange part was pretty awesome.

And so they were gone, and there I was in a pitch-black gas station, exhausted, miles from anywhere.

A door creaked. An old man emerged from the gas station shack. We looked each other over. He pointed to a rust bucket car and then gestured into town. I gave him a pen and some paper and made the sign for money. He wrote down "300."

"Three hundred som?"

"Yes. Som."

"Okay! Yeah!"

When I got to my hotel, the adrenaline drained from my body and I fell apart. I hid in my room for two days. I had written off Kyrgyzstan. I simply wanted to wait out my time and leave.

I called Melissa and she talked me out of my stupor. With her prodding, I cautiously ventured out during the day.

By the way, you don't ever want your hotel room door to look like this.

There was a lingering Soviet vibe to Bishkek.

Most everyone seemed to speak Russian, and the trademark austere and bland architecture was omnipresent. They even had the obligatory Lenin statue.

While I was buying food from a street vendor, an English translator named Helen overheard me babbling and struck up a conversation. I told her I wanted to get out of the city and see the mountains. She pointed me toward Ala Archa Gorge and even went as far as calling a cab for me the next morning. She told the guy where to go and negotiated a price.

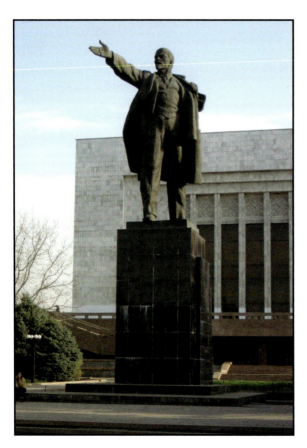

ALA ARCHA GORGE, KYRGYZSTAN

Out in the countryside, the air was clean and the mountains were swell. I saw packs of wild teenagers enjoying the great outdoors.

I hiked up into the mountains and found a sufficiently majestic vista to dance in front of.

A group of teenagers caught me on the way back down to the parking lot. They spoke a bit of English and found me fascinating when I told them I was from California. Note: always tell everyone you're from California. There were lots of questions about America and what the hell I was doing in their country.

I explained the nature of my profession and invited them to join me in a dance. They didn't really get it until I mentioned it was going on YouTube. Then suddenly they were keen.

After all I've seen, you'd think I'd have learned not to judge a place by one bad experience. You'd think I'd be a little more enlightened. But no, I'm driven by the same old anxieties, and I often let fear get the better of my curiosity. In Kyrgyzstan, I'm glad curiosity won out in the end.

Gurgaon, India

"Excuse me, sir. You have something in your ear?"

"What?"

"Your ear, sir. Let me help you."

Before I could react, the man had grabbed my ear and stuck a cold metal rod deep inside it.

I was walking along the waterfront near India Gate in Colaba, a hub for tourists and the street touts who prey on them. I had landed only a couple hours prior, and though I knew not to respond to or even look at anyone who spoke to me, I was unprepared for this most aggressive invasion.

When the man extracted the rod from my ear, he held it in front of me to show off the enormous glob of wax on the end.

"You see, sir? Very bad. This will help you."

Maybe it really was my earwax. I'm pretty sure it wasn't. It didn't really matter. I ran in horror.

GURGAON, INDIA

India has a tendency to overwhelm people. At first, you respond to the surface qualities: the overcrowding, the poverty, the filth. But in time you become attuned to an underlying peace, beauty, and understanding.

At least that's what I'm told. I've spent a lot of time in India. I never really had that moment of revelation. I suppose that says more about me than the place itself. I wanted to make amends, in a way, by representing that deeper side of the country. Unfortunately, I hadn't the faintest idea how I was going to do that.

I called Melissa back in Seattle and asked her if she might have any interest in tracking down a Bollywood dance troupe.

"When do you need them?"

"Uh. It'd pretty much have to be in the next two days."

And so she got cracking. Melissa works in human resources. She's very good at finding people who have specific abilities. Within a few hours, she'd spoken to several dance choreographers and found one in Delhi named Rahul who said he could do it.

She worked with him on the number of dancers, the costumes, the budget, and the location, and by the time I landed in Delhi, we were ready to go.

Rahul picked me up on the street outside a giant Bollywood movie theater. His wife, who would be dancing with me, was in the car along with several of his students. He explained that several more carloads would be following behind us.

We drove out to a farmhouse near Gurgaon. Farmhouses, Rahul explained, are well-groomed estates that can be rented out for weddings, parties, and on occasion film shoots. I'm not sure "estates" is the right word. The one we rented was a lawn with a stage in the middle, but it was perfect for our needs.

As Rahul's students arrived and got into costume, he trained me in Bollywood Dancing 101. I learned a few basic moves and we strung them together into a routine that I could perform with the other dancers.

I found it incredibly challenging to carry out the movements he was showing me, despite their apparent simplicity. As a grown man in my thirties, I regret that I have not cultivated the ability to hoist my body around in a coordinated fashion. As a professional dancer, I recognize that this is deeply ironic.

I am well aware of how fun it is to dance badly. After only the slightest bit of focus and repetition, I began to feel the tremendous satisfaction of dancing well. I am interested in exploring this further.

Rahul and I tried out various ways to finish the routine. He suggested a move that involved sticking both hands out, palms forward, and shaking them wildly. He called it "Juzzans."

"Juzzans?" I repeated.

"No, no. Juzz Ans."

"Just Hunds?"

"Juzz Ans! Juzz Ans!"

And that's how I learned to do Jazz Hands.

As the students emerged from the bathrooms, we moved over to the stage. I watched Rahul polish the routine.

The dancers in their full makeup and costumes were stunning. I felt humbled, unprepared, and totally out of place.

I hopped up onstage and we started shooting. The bright sun made the colors brilliant, but it also created an intense, punishing heat.

We ran through the routine over and over. Each time it got a little better, and each time I got a little sweatier. I finished the two liters of bottled water I'd brought and found myself still desperately thirsty.

At long last, we got it right. And of the hundreds of dancing clips I've shot, it is, perhaps, the most beautiful.

All of us were exhausted. A servant appeared with a tray of glasses. Someone handed me one. I examined the swirling particles, imagining the untold microbes and bacteria

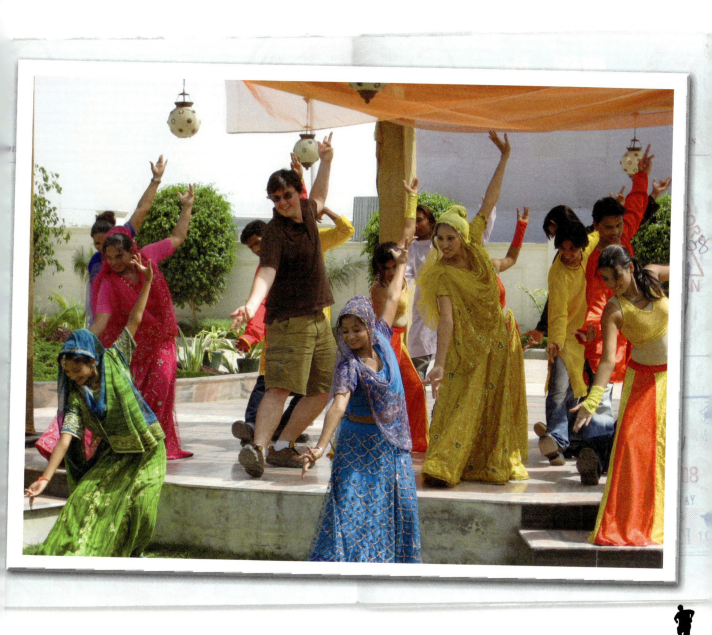

within the warm tap water. Then I considered my options, and how close I was to collapsing from dehydration. I downed two glasses.

To celebrate our success, Rahul and a few of the dancers took me out to lunch back in Delhi. The food was delicious. It was also splattered across the tables and walls. Dishes and trays were stacked on the floor with swarms of flies buzzing around them. The clientele, packed as densely as possible into the narrow, multiple-story shack, relieved their various phlegm-related blockages openly, visibly, and with a vigor one could almost call showmanship.

Between the meal and the tap water, the next few days left me with an enduring gastrointestinal reminder of my visit. As I said, I never quite had that moment of revelation, but I think now, having danced together, we are at peace, India and me.

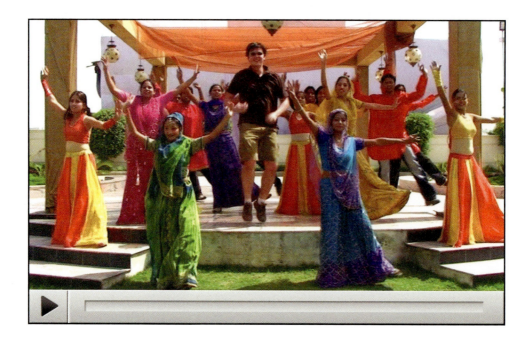

Alhambra, California

 I spent a year worrying about the music for the third video. I knew Garry would come up with a brilliant composition, but the vocals are the soul of the song and neither of us had the faintest idea what to do. We needed something new.

 We debated coming up with lyrics, but neither of us are lyricists and we couldn't imagine finding words to match what was happening onscreen. It would be far too easy to slip into clichéd blather about world harmony, and that just wasn't needed. What *was* needed was a voice that reflected the spirit of the imagery in abstract form—something graceful but raw, relatable but unfamiliar.

 It struck me one day that there were a whole bunch of other languages besides English that the song could be sung in, and there were many benefits to be had from going that route. In hindsight it seems dumb that it took me a year to stumble upon the formula I'd already been using to great success in the previous videos. Nevertheless, that is what happened.

Garry agreed that we should find a language that would be foreign to most listeners, but that didn't really get us anywhere, as neither of us are experts on world music.

Out of the blue, Garry suggested I read an Indian poet named Rabindranath Tagore that he was familiar with. Tagore won the Nobel Prize in 1913 for a book of poems called *Gitanjali*. He was a friend and contemporary of Mahatma Gandhi and an accomplished world traveler. I read an English translation of *Gitanjali* and was drawn to a poem called "Stream of Life."

> The same stream of life
>
> that runs through my veins night and day
>
> runs through the world
>
> and dances in rhythmic measures.
>
> It is the same life
>
> that shoots in joy through the dust of the earth
>
> in numberless blades of grass
>
> and breaks into tumultuous waves of leaves and flowers.
>
> It is the same life
>
> that is rocked in the ocean-cradle
>
> of birth and of death,
>
> in ebb and in flow.
>
> I feel my limbs are made glorious
>
> by the touch of this world of life.
>
> And my pride is from the life-throb of ages
>
> dancing in my blood this moment.

It said precisely what I wanted to say, and it said it beautifully.

So then we faced the hurdle of finding someone who could sing "Stream of Life" in its original Bengali. We agreed on a female voice. We considered hiring a studio singer in L.A. and teaching her the words phonetically, but I recoiled at the thought of how it would sound to a native speaker. No one wants to hear their language butchered. Also, so much of the beauty in every language comes from the subtle intonations and nuances that can only develop from childhood.

Again, we were stuck. Sure, you can just sit around and say, "You should find someone who can sing it in Bengali," but how does one actually go about finding that person?

Enter Melissa.

"Hey, do you feel like poking around the Internet?"

ALHAMBRA, CALIFORNIA

It took her half an hour. She found a video on YouTube of a Minneapolis radio station interviewing a young girl named Palbasha Siddique. A few minutes into the dark, grainy video, Palbasha broke into song. I leapt off the sofa a few feet away and asked, "What's that?!"

I tracked Palbasha down through the radio station and spoke to her on the phone. She was seventeen, having just finished her junior year of high school in Minneapolis. She grew up in Bangladesh and spoke the language fluently. She knew Tagore well—which I now know is true of most Indians and Bengalis. She dug out her copy of *Gitanjali* and threw together a demo for us, singing "Stream of Life" in its original form.

Garry, Melissa, and I were floored. There was simply no question for any of us. I booked tickets for Palbasha and her mother to come out to Los Angeles to record the song.

Palbasha was radiant and disarmingly professional, but the pressure was on; we had two hours of studio time to sort out how the music and lyrics fit together. They were two pieces from two entirely different jigsaw puzzles. We could've had a hundred different compositions with a hundred different sets of lyrics, and I doubt any of them would have blended so miraculously. We found the verses, we found the chorus, and we were done.

There were tears in the control booth.

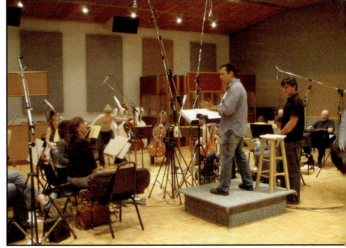

Next came the strings. It bothered me a little when we put out the 2006 video and few people realized the song was written and performed specifically for that video. I felt that Garry's contribution had been overlooked. I wanted people to know that we didn't just slap some MP3 on there. So I asked Garry to let me shoot a dancing clip while he was conducting the orchestra.

In my head, it seemed like an elegant acknowledgment with a clear message. In actuality, it didn't work out that way at all. The shot was too far away and the edit was too fast for viewers to process.

Instead of the response I was hoping for: "Hey, that's a live orchestra playing the song!" I got: "Hey, why the hell are you dancing in Alhambra?"

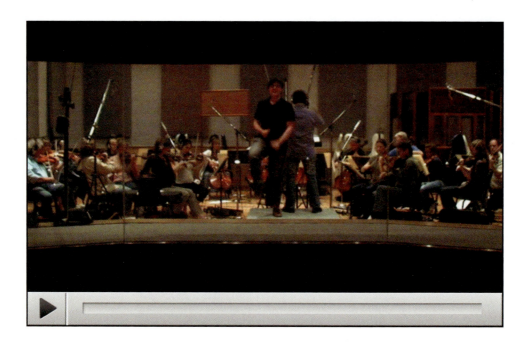

Seattle, Washington

Melissa and I shot the final clip of the video in Gasworks Park. All our friends and family turned out to dance.

As we gathered, we noticed another crowd on an adjacent hill. It was a meeting of cosplayers. Cosplay is a fairly recent phenomenon: fans dressing up as characters from their favorite movies, TV shows, comics, and videogames—primarily those of Japanese origin.

There was great speculation over whether they'd want to dance with us. I chose the most colorfully dressed members of our party, declared them emissaries, and sent them over to see if the cosplayers wanted to join in.

Evidently, the talks went well. The kids knew the video and were excited to participate, so we got an unexpected infusion of weird/awesome.

We even had a Waldo, but alas, he refused to dance with us. I remain devastated by the snub.

The moment we finished dancing, the clock started ticking in my head. I had thirteen days before the deadline.

Melissa and I spent a lot of that time trying to work out the right sequence of video clips. I made little cards for each clip and put them up on three giant foam boards which we spread out across the living room floor.

Editing the video was like trying to solve an enormous sudoku puzzle. I'd place all the clips in some sort of order based on tone, color, energy, and location, then run it off my laptop onto the TV. When I found a clip that was in the right place, I'd stick a pin in it and set about trying to find its neighbors.

What comes after Miami, Florida? Munich, Germany, of course. Why? It just does. Trust me. If there's one genuine, *bona fide* skill I employ in this whole endeavor, it's that one. I'm a good editor.

Three days before the deadline, I rented out a local Seattle theater for the big premiere. Our friends and family, who'd danced

with us just a few days prior, showed up to see what we'd put together. My dad even flew out from Connecticut for the occasion.

Only a handful of people had seen the video up to that point. I was wracked with anxiety. But they laughed, and they cheered, and they cried, and they demanded to see it over and over. Watching the video simply made them feel happy. And what's better than that?

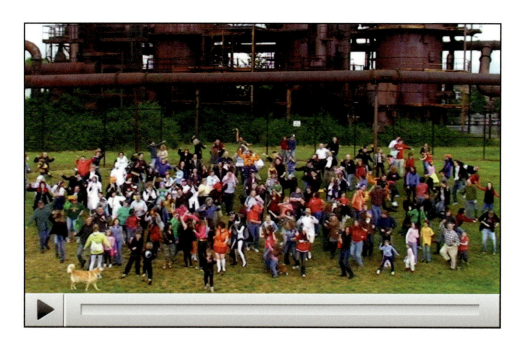

Conclusion

I uploaded my third dancing video to YouTube before dawn on Friday, June 20, 2008. Before the weekend was out, 2 million people had tuned in. Within the first month, it was viewed over 10 million times.

The *New York Times* devoted the front page of their Arts section to six full-color stills from the video. They called it an "almost perfect piece of Internet art." And for that, I am willing to overlook their description of me as a "big, doughy-looking fellow."

Time magazine called *Where the Hell Is Matt? 2008* the best viral video of the year, three whole places above *Hamster on a Piano (Eating Popcorn)*.

A NASA-affiliated site named the video as their "Astronomical Photo of the Day." This is astounding, as it is neither "astronomical" nor "a photo."

I received widespread reports detailing unexpected, uncontrollable outbursts of wet, drippy emotion. I think the video provided something a lot of people were longing for: a sense of being connected. It is humanist propaganda—a wildly exaggerated view of the natural joyfulness and good will of our species. It shows us at our best in the hope that viewers will behave accordingly.

I spent that first month traveling constantly for interviews.

One night, during the media tour, I lay alone in bed, exhausted but restless, trying to process all that was happening. It struck me that in all the excitement, I'd never actually *watched* the video. I mean, sure, I'd pored over it hundreds of times while putting it together, and I'd viewed snippets in TV studios while bright lights shined on my face. But I hadn't yet taken the time to really watch it.

I pushed everything else out of my head, set the laptop on a chair next to the bed, and let it sink in.

I watched for a solid hour, maybe more. And I forgot about the audio mix and the colors and all the other fiddly bits I'd been obsessing over. Each time, when it finished, I let it play again. And each time, I felt more absorbed, but at the same time removed from the guy on the screen and all that he'd been through. I watched him passing effortlessly

around the world. I watched him sharing moments of joy with complete strangers. I watched this ordinary guy with the inexplicably good fortune to fill his life with extraordinary experiences, preserve them, and share them with so many others.

I started feeling jealous of myself, which was confusing, but that soon gave way to stronger emotions. And because so many others have admitted it to me, I can say that I had tears running down my face.

I suppose I was looking for something when I started traveling. I suppose it's the same thing everyone is looking for, and we each find it in our own way. Watching the video made me feel less alone. And that meant the journey was over.

Acknowledgments

A special thank you to Melissa for more than I can fit on one page, but most of all for her love and support.

To Doug Stewart for seeing the possibility and sticking with me.

To Bill Wolfsthal for remaining calm and supportive through my many missed deadlines.

To Jennifer McCartney for helping me fish a story out of a sea of anecdotes.

To Wynn Rankin for suggesting that maybe I should have a point.

To Stacy St. Onge for noticing the details.

To Brad Welch for a goofy idea that set me on my path.

To Emily Liu, Christine Briganti, Steve Gold, and the Stride gum team for giving me the opportunity of a lifetime and then giving it to me again.

To Garry Schyman, Craig Kessler, Palbasha Siddique, and the thousands of other people who helped me make the dancing videos.

To my father for talking me out of college.

To my mother for coping with the consequences.

And to Afunakwa, wherever she is, for her voice.